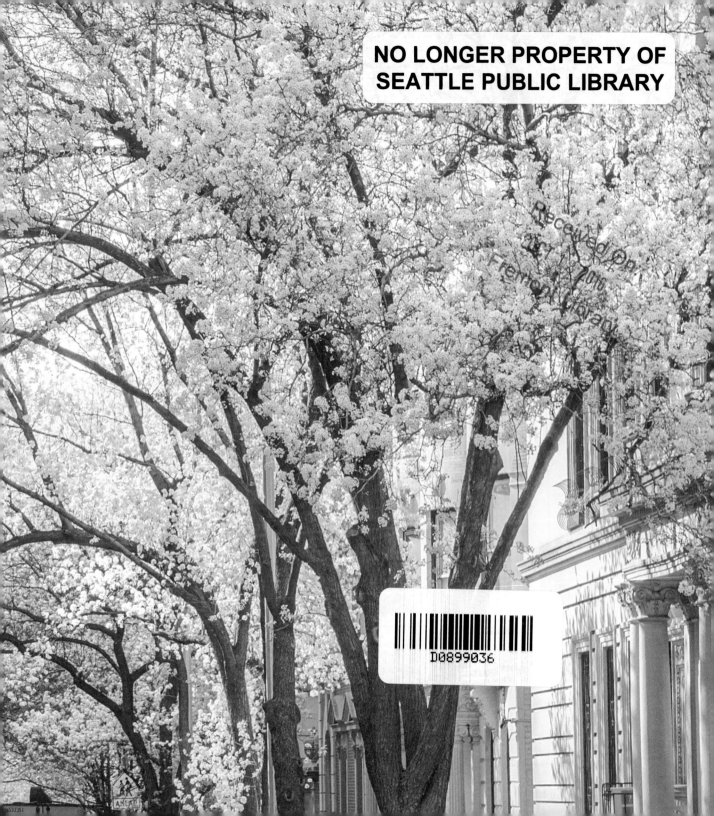

Sidewalk Gardens *of* New York

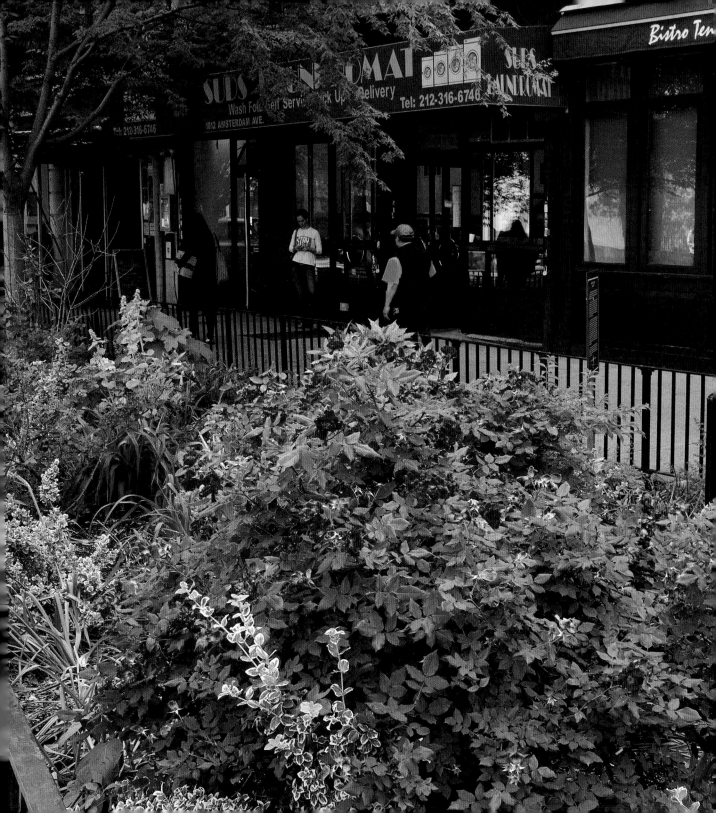

Sidewalk Gardens *of* New York

Photographs by Betsy Pinover Schiff

Foreword by Adrian Benepe
Text by Alicia Whitaker

THE MONACELLI PRESS

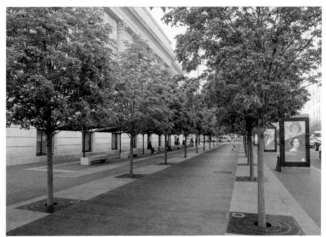

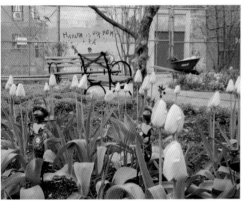
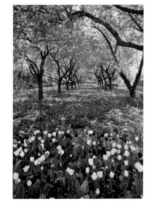
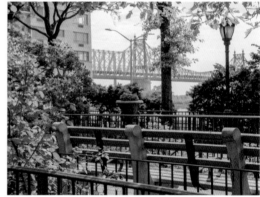

Preceding spread: The Minerva Bernardino Greenstreet, a wide planting strip on Amsterdam Avenue, near the Cathedral of St. John the Divine, honors a Dominican diplomat who was one of the original signers of the United Nations Charter.

This vibrant garden, featuring red Carefree Wonder roses and other small shrubs and perennials, is part of the Greenstreets program to transform paved traffic islands and medians into green spaces.

Above: Spring plantings throughout Manhattan.

Contents

Foreword

Adrian Benepe

As a teenager in New York City in the 1970s, I got a summer job with the Department of Parks and Recreation working on the Lower East Side. The city and its park system were at the lowest point in their three-hundred-year history. This was not "Barefoot in the Park," but rather "The Warriors" meets "Escape from New York." The park experience was, in the words of Thomas Hobbes, "poor, nasty, brutish, and short." The landscapes were barren and the park buildings largely abandoned. There was no hint of beauty anywhere in the city—except in small pockets such as the Park Avenue Malls, where philanthropist Mary Lasker and her neighbors funded plantings of tulips and annuals.

The municipal abandonment of public space was very apparent in 1979, when I signed on as one of the first Urban Park Rangers. Even the flagship Central and Prospect Parks were dangerous, crime-ridden, covered with graffiti, and untended, their meadows and hills denuded and ornamental gardens flowerless.

And yet I found my vocation, encouraged by Betsy Barlow Rogers, the first Administrator of Central Park. Betsy would go on to found the Central Park Conservancy a year later. Among her first acts was to reintroduce the art and science of horticulture to Central Park, working with Parks Commissioner Gordon J. Davis to restore the dust bowl of the Sheep Meadow to lush green glory and renew the landscapes across the park, including the Conservatory Garden.

A few years later, working under Commissioner Henry J. Stern, I learned that there were only thirteen gardeners to take care of 25,000 acres of parkland, and I worked with colleagues to create new paths of entry and training so we could recruit, hire, and educate gardeners to till the hardpan soil, replenish it, and restore pockets of beauty across the city.

Stern had an even bigger vision. He looked at all the odd corners of the city where streets and avenues met at angles, leaving behind triangles of asphalt or concrete, and he saw thousands of tiny oases of greenery and flowers. He and Transportation Commissioner Ross Sandler created the first "Greenstreet" at Sheridan Square in Greenwich Village, working with green-thumbed neighborhood residents to transform the tiny asphalt triangle into a Lilliputian Garden of Paradise. Another early Greenstreet, featured by Betsy Pinover Schiff in this lovely and thoughtful Baedeker of beauty, was the enlarged corner at 110th and Amsterdam Avenue. Almost 3,000 Greenstreets later, with a significant boost from Mayor Michael R. Bloomberg, New York City's parks and tiny, odd patches of green are redefining neighborhoods and urban quality of life.

This work of horticultural alchemy was hardly the sole province of bureaucrats. Beginning in the 1960s, citizens and block associations fought to plant trees and add flower boxes. Philanthropists made the extraordinary Greenacre Park on East 51st Street, and community residents turned hundreds of abandoned lots into demi-Edens of flower- and vegetable-producing community gardens across the city.

The rest, one could say, is history. Almost four decades of work by public and private partners have completely transformed New York City, its parks, corners, and even its once-abandoned waterfronts and rail lines into spectacular parks and gardens; a wonderful selection of these thousands of landscape interventions, from sweat equity digs to grand public projects, from petite to XXL, is documented in *Sidewalk Gardens of New York*. I was privileged to serve for almost twelve years as Parks Commissioner under Mayor Bloomberg, working with public and private partners to rebuild and expand the New York City park system at a scale that would have seemed unimaginable to the teenage me of 1973 raking up hundreds of empty beer cans in a forlorn East River Park.

It is safe to say that the transformation of New York City from Dante's seventh circle of hell into a new paradise represents the city's most spectacular renaissance among many. But don't take it from me—Betsy Pinover Schiff's unerring eye and spectacular photographs tell the story of a city, and how its pre-Dorothy and Oz, colorless and downtrodden existence has been redone as if by wizardry in glorious Technicolor.

Introduction

Over the past fifteen years, the sidewalks of New York City have been transformed by plantings at every scale. Vibrant tree beds and window boxes, serene pocket parks, active community gardens, and expansive new waterfront parks have all brought color and life to the urban fabric, to the delight of visitors and residents alike. The greening of New York has been underway for decades, but this greening—and flowering—is suddenly obvious as you walk down the sidewalks in any borough.

Gardens along the sidewalk are an increasing part of life in the city, as homeowners, businesses, city agencies, and public/private partnerships have brought planted pots, curb gardens, hanging baskets, pedestrian plazas, and pocket parks to the blurred edges of public and private spaces. There have always been wonderful hidden gardens behind townhouses or on terraces and rooftops, but now there's a lot to see out in the open for pedestrians walking in residential and commercial areas of New York, making for a friendlier, more attractive, and more gracious city.

America's densest big city has seen a significant growth in parkland, a revitalized "Blue Network" of waterways, a proliferation of walking and bike paths, the creation of pedestrian plazas, and the achievement of the MillionTreesNYC campaign. Many streets in Midtown Manhattan feature large pots with abundant seasonal plantings, and tree beds throughout the five boroughs are gardened by homeowners, block associations, and other groups. The private and public spaces in front of commercial and residential buildings are planted with large containers, window boxes, and front gardens that are about delighting passersby as much as they please the occupants. Fifteen years ago, only Park Avenue had a beautifully planted median strip or mall, but now they have been introduced in many other parts of the city. The gritty edges of the city have been softened with flowering plants, trees, shrubs, and water features.

This book challenges the traditional definition of "garden." It's clear that we need another way of thinking about gardening in an urban environment. There are planting beds and borders within parks that meet our traditional expectations, but there are also areas planted by people working to bring beauty, color, flowering plants, and vegetables to their neighborhoods, using whatever resources they have to hold soil and plants. In the city, a garden can be found in something as small as a window box or potted plants on a stoop. And the plant palette is now more diverse, expanded to include perennials and grasses with four-season interest.

There are a number of reasons for the greening of New York, including the fact that people have demanded more natural beauty in their surroundings—we city dwellers crave access to nature. Government has responded with several long-reaching initiatives, and there has been significant growth of the use of private funds to support public parks. The Central Park Conservancy, the Friends of the High Line, and the Battery Conservancy are examples of the success of this approach, with public money providing a foundation and private money supporting the enhancement and ongoing maintenance of these spaces. Conservancies, community groups, and business groups are helping to fill the gap between the need to create and maintain green spaces and the city's budget for parks. Groups such as New Yorkers for Parks and the New York Restoration Project raise their voices and provide funding to help, and there has been a proliferation of community organizations that teach residents how to garden and provide space for allotments. Under former Mayor Michael Bloomberg, more than 800 acres of new parkland were added, including major developments along the Brooklyn, Queens, and Manhattan waterfronts. The Battery Park and Chelsea waterfront gardens have matured and become even more beautiful. As Frank Bruni of the *New York Times* wrote about the greening of the city, "Amazingly, we're getting it: because citizens have demanded as much; because governments have made it a priority; because public and private partnerships have been cultivated. New York is the bright flower of all that."

The MillionTreesNYC campaign has resulted in a significant increase in street trees as well as trees in parks in all boroughs, with the number of street trees up 30 percent since 1995, including areas of the city with previously barren blocks. Trees play an invaluable role in creating shade and reducing air pollution, and tree beds

provide space for creating the curbside gardens that are an important part of the story of the greening of the city. The Greenstreets program was initiated in 1996 by Parks Commisioner Henry Stern with the goal of "greening the corners" and planting small interstitial spaces like traffic triangles and median strips.

In the early 1990s, New York was a tough and dangerous city; it would have been unthinkable to use planted pots on a townhouse stoop and landscaped tree beds on the street for fear of theft or vandalism. The decrease in lifestyle crimes in the city over several decades has made it more feasible for businesses and homeowners to use planted containers in front of their buildings. There's an "eyes on the street" dynamic that leads to the protection of plantings that are enjoyed by the public. This is true in neighborhoods throughout the boroughs, and it's telling that a recent winner of the Greenest Block in Brooklyn competition was a street in Bedford-Stuyvesant, where tenants as well as homeowners maintain exuberant plantings in formerly vacant lots and along streets lined with renovated homes.

People thrive with access to nature, so it makes sense that New Yorkers are demanding and enjoying more access to parks and a beautiful streetscape. Making a garden, however small, is a human drive that spans across cultures and through the centuries. Growing food may be a primary need, but close behind that is the need to delight the senses—we yearn for beauty and wildness. Recent scientific studies have documented the positive impact of trees and access to nature on the brain; even gazing at a tree out a window apparently makes a difference. We need to find places for respite from the cacophony and activity in a city; hence the popularity of plazas, especially those with water features, and pocket parks that provide a serene space to get away.

The growth of community gardens is a development that reflects the elemental need to have one's hands in the soil, to grow food and flowers, and to enjoy the company of other gardeners. In addition to nurturing a bounty of vegetables, community gardens provide a platform for learning and fellowship—the building blocks of community development. Most community gardens have a gathering spot such as a pergola with table and chairs, benches, or similar places to linger and rest.

Looking toward the future, recent initiatives include a plan to invest in long-neglected small parks in underserved neighborhoods, the completion of the East River Waterfront Park, the master plan for Governor's Island, including the opening of The Hills in summer 2016, and the creation of the 2,200-acre Freshkills Park, a landfill reclamation project on Staten Island and the largest park to be built in the city in a century. There's a growing demand for the creation of ecologically sustainable and organic gardened spaces, and this development will become increasingly relevant to sidewalk gardeners as well as the makers of parks. All of these larger initiatives provide a context for smaller efforts to extend natural beauty through sidewalk gardens.

We hope that you find inspiration and ideas for your own urban garden plantings, which will contribute to creating gardened cities everywhere. Our Edens should be no further than our front doors.

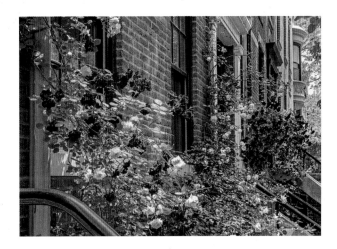

Along the Street:
Flowers and Foliage

Perhaps the most visible real estate that has been appropriated for gardens are the many tree beds throughout the city. Supported by the MillionTreesNYC campaign, thousands of street trees have been planted and residents have been instructed in their care. Homeowners, block associations, and public/private partnerships now make sure that trees are well watered. The small spaces around trees are seasonally filled with flowering bulbs, annuals, and small shrubs, and they are often surrounded by decorative tree guards, leading to better protection for the trees as well as the creation of small gardens. Sometimes block associations oversee coordinated planting of tree beds on one or several blocks. A recent Greenstreets initiative is the development of bioswales, expanded tree beds built to absorb storm water.

The other very visible development is the use of large planted pots and other containers to create a sense of enclosure or protection along pedestrian plazas and in front of commercial buildings. Block associations, managers of commercial buildings, and public/private partnerships such as the Flatiron/23rd Street Partnership maintain seasonal plantings. In place of unadorned bollards, many commercial buildings use large containers of flowers and foliage as a way of providing security for the entrance.

Where space to garden is limited, ever-resourceful New Yorkers use vertical space, installing hanging baskets and other containers to delineate a special venue or to provide unexpected beauty.

A mix of yellow, pink, and Queen of the Night tulips, repeated in the tree beds on the same block of Fifth Avenue, announces that spring has arrived on the Upper East Side.

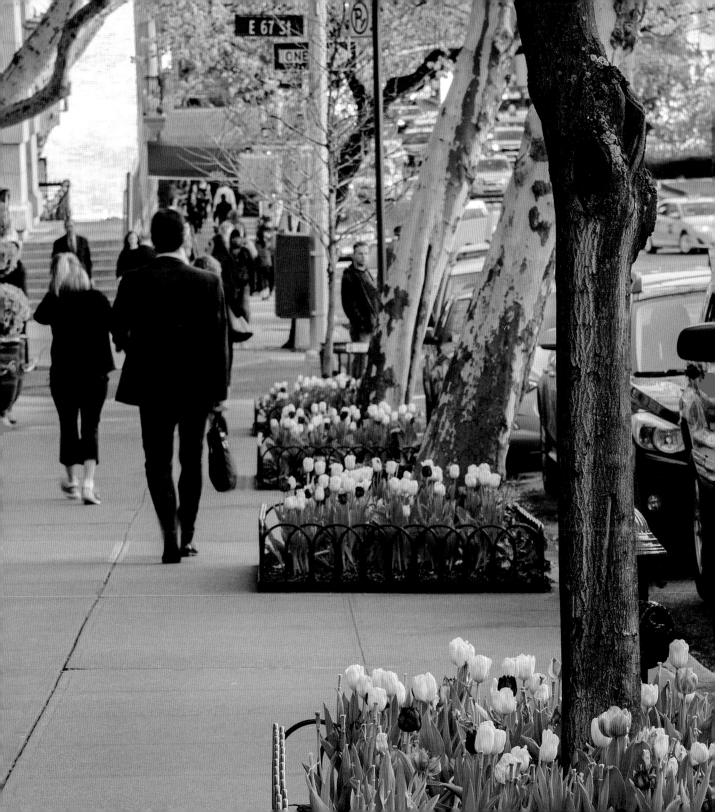

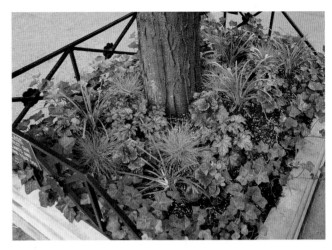

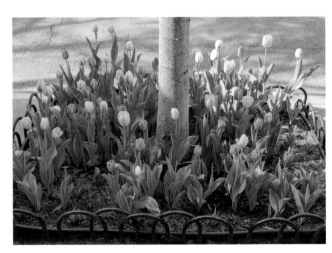

Annuals, perennials, small shrubs, and bulbs are all good candidates for seasonal plantings. These tree beds demonstrate the power of limiting the color palette and number of plant varieties.

Clockwise from upper left: White impatiens and silver dusty miller; a mixed border, with dark-leaved coral bells, begonias, dracaena, and ivy; a luxuriant mix of warm-toned tulips; boxwood border surrounding a variegated vinca groundcover.

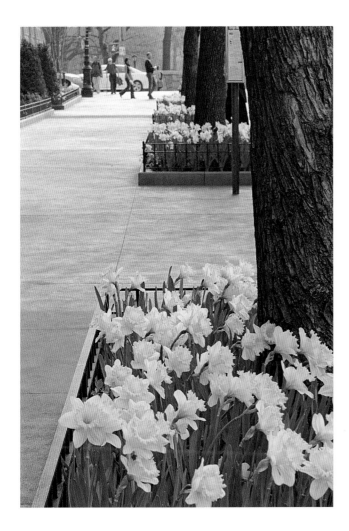

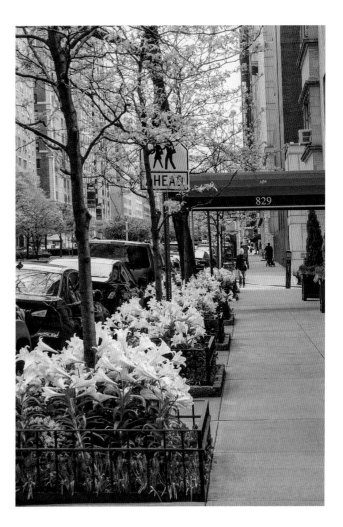

Above: Identical plantings on the same block make a strong statement. The daffodils, all one variety and height, provide longed-for color after a gray winter. The tall and luxuriant lilies are underplanted with small spring bulbs, adding more color and masking the lily stalks.

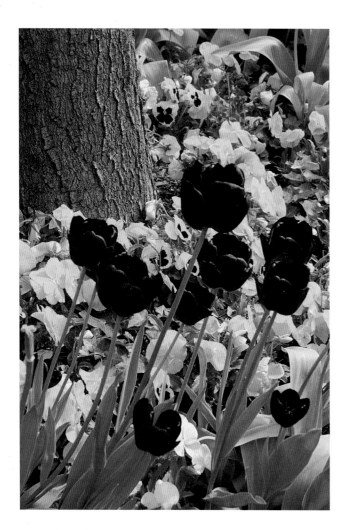

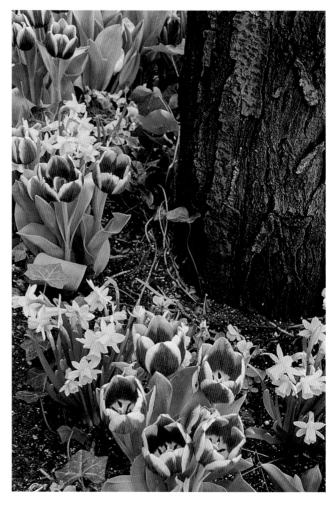

Above: Two spring combinations: Queen of the Night tulips interspersed with yellow pansies and bold red and yellow tulips mixed with miniature yellow daffodils.

Opposite: The shade planting of coleus and ivy features foliage color; the dusky burgundy, coral, and lime-bordered coleus glow in a summer-green border of ivy.

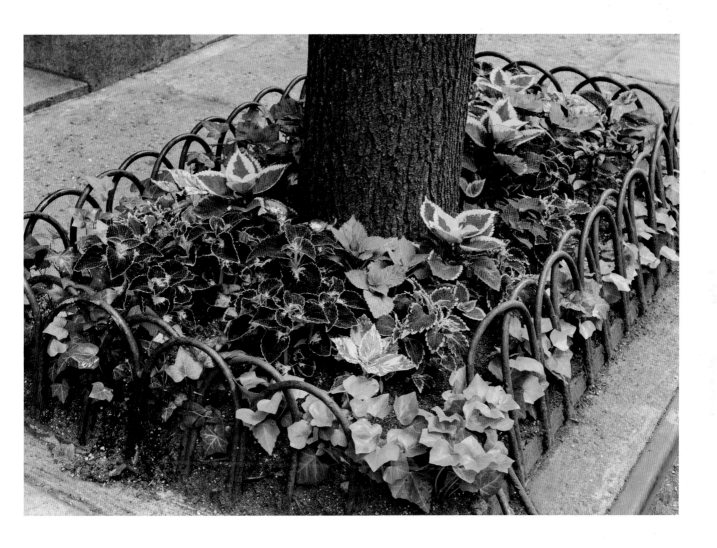

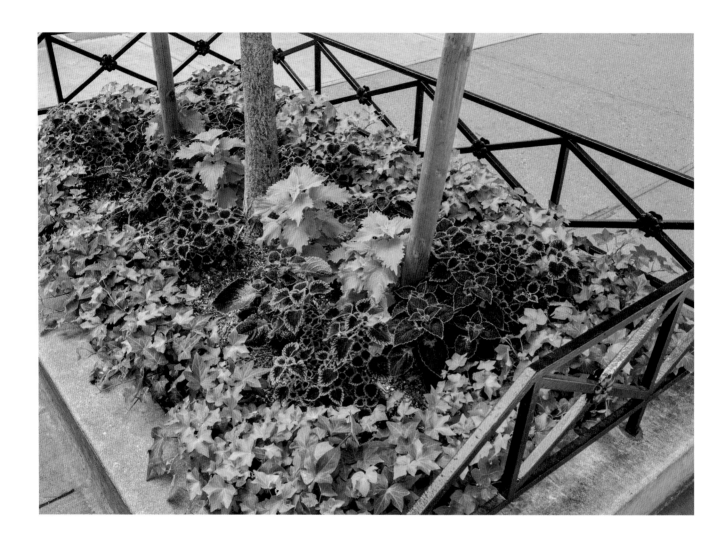

Above and opposite: Coleus, ivy, and ornamental cabbages create an attractive combination of dark purple with bright green, showing the impact of colorful foliage.

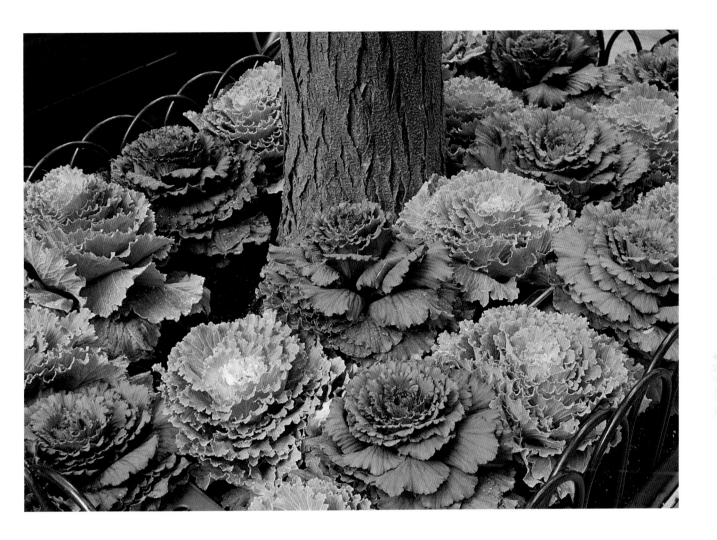

The median in front of Lincoln Center is the beginning point for the Broadway Mall that runs through the Upper West Side to Harlem and Washington Heights, planted and maintained by the Broadway Mall Association. Flowering crab apple trees are having their moment as nearby foliage trees are beginning to bud.

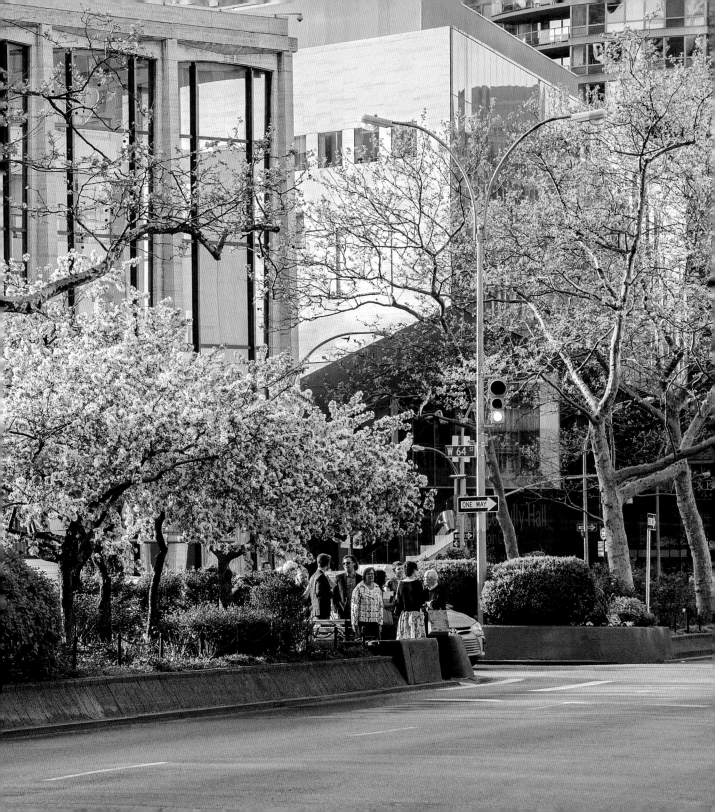

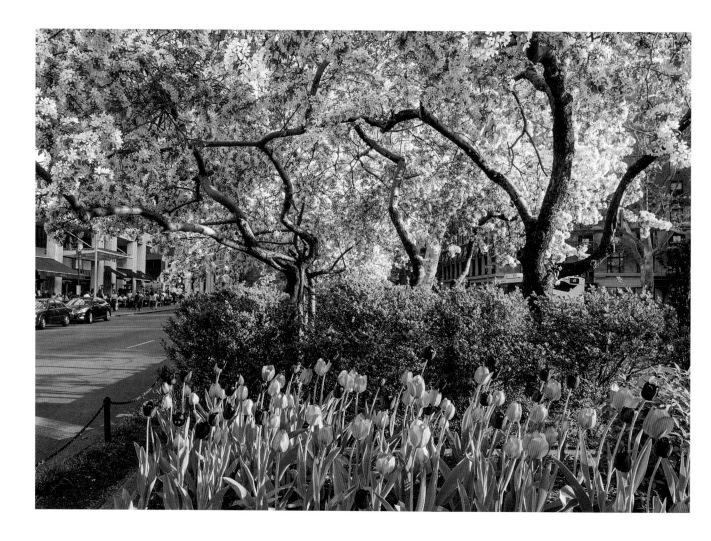

Above and opposite left: Cherry trees and crab apples provide a floral canopy for an array of mixed tulips, a meadow-like garden in the middle of the Broadway traffic. The Broadway Mall Association treats many of the medians as pocket parks, providing seating as well as plantings. Tulips are replaced with annuals for the summer.

Opposite right: The Fund for Park Avenue manages the plantings on the Park Avenue Malls. Flowering cherry trees, bordered by a low yew hedge, and massed tulips provide an iconic image of New York in the spring, while the parade of lighted Christmas trees up the avenue epitomizes the holidays in the city.

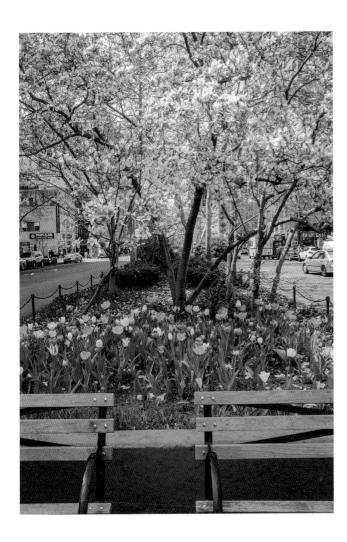
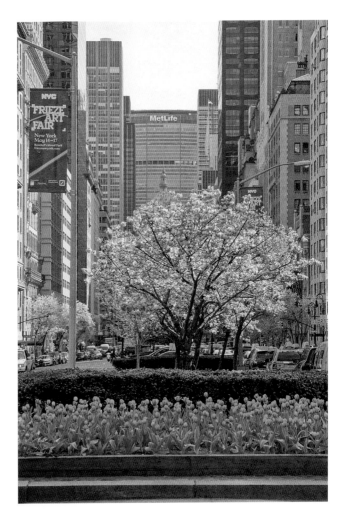

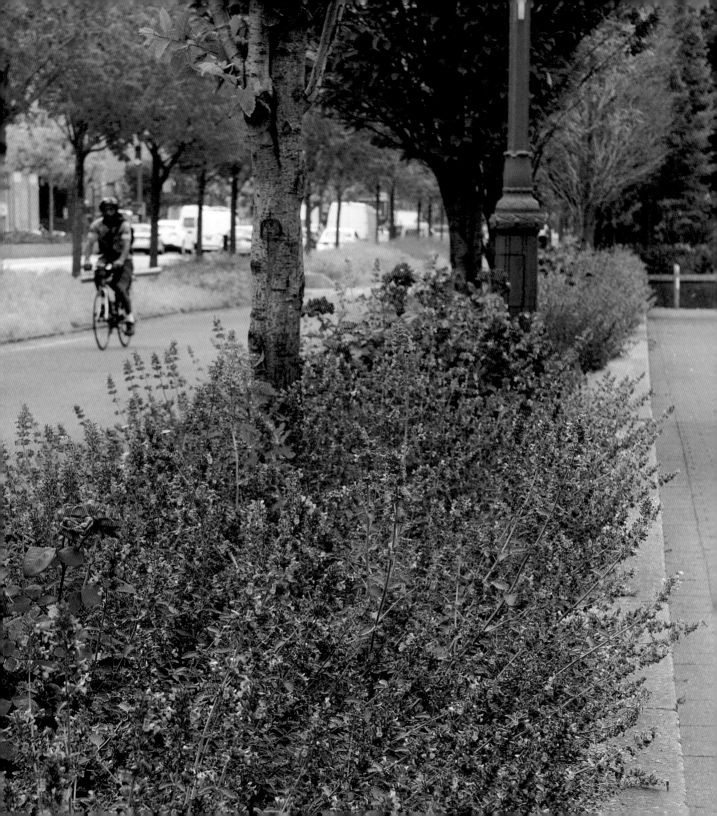

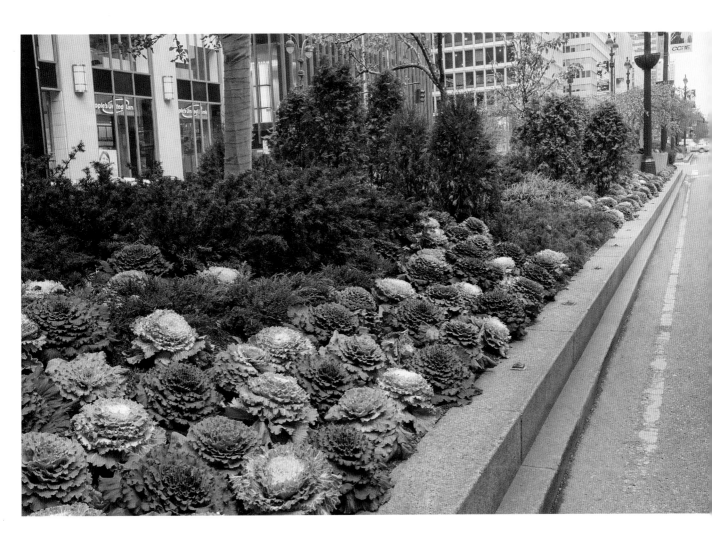

Opposite: The Manhattan Waterfront Greenway in Chelsea features roses and catmint, traditional cottage garden plants, thriving in their urban waterside environment. Both plants grow well in sunny, relatively dry conditions.

Above: Ornamental cabbages provide months of color in the midst of the traffic on this busy stretch of Park Avenue.

Overleaf: Oversized pots with lush plantings embellish a Midtown Park Avenue sidewalk. Tulips and hyacinths, with a smattering of pansies, provide color and fragrance for several weeks in the spring.

25

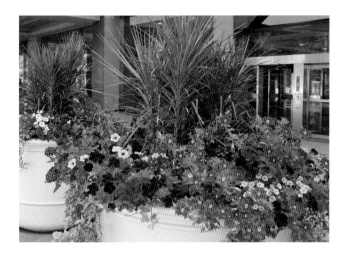
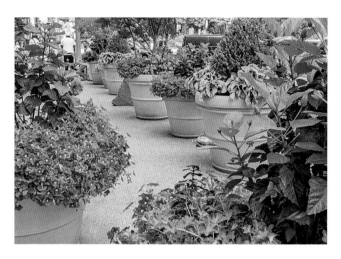
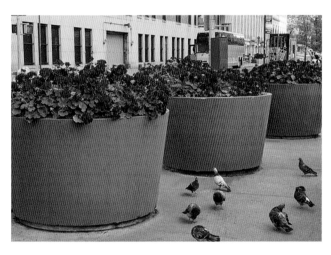
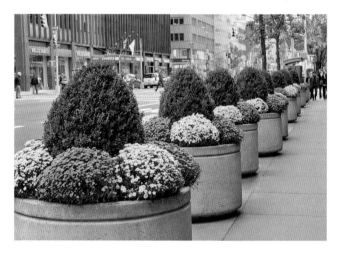

Large pots often define pedestrian plazas and they can also serve as security or traffic bollards.

Clockwise, from upper left: Tall grasses and masses of petunias form a vibrant border on Park Avenue; lushly planted pots define a path through the plaza north of the Flatiron Building; protective security bollards house evergreen shrubs and mums in heavy pots along Third Avenue; massive bright-red pots hold equally bright-red geraniums near the Rector Street subway entrance.

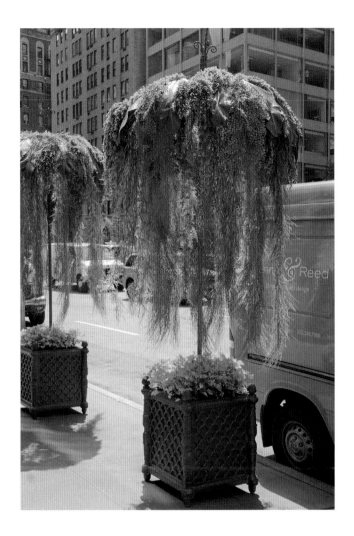

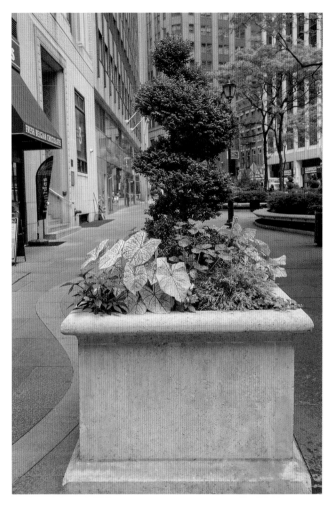

Above, left: Florists Renny & Read place ornamental pots on the sidewalk in front of their shop on Park Avenue, often reusing materials from private parties, like this whimsical mix of artificial and real plants in Versailles planters.

Above, right: Rectangular planters help to delineate the boundaries of the Queen Elizabeth II September 11th Garden. The topiary evergreen spiral makes a distinctly English garden statement.

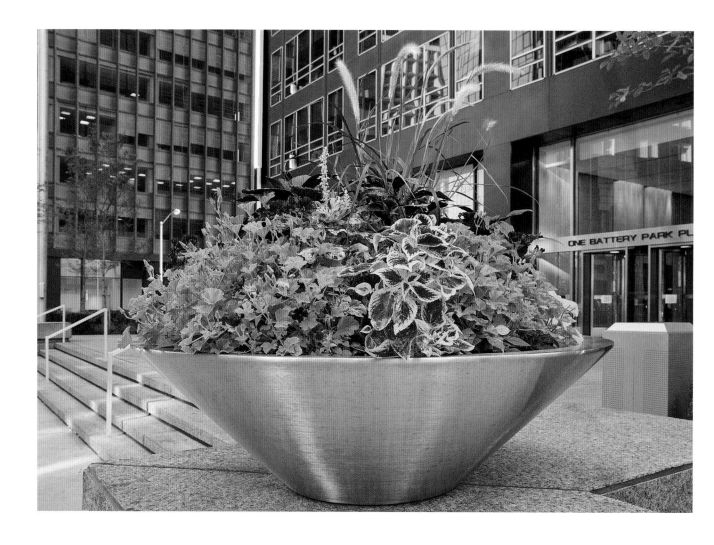

Above: A low stainless-steel contemporary bowl complements the architecture at One Battery Park Plaza while a luxuriant mix of geraniums, coleus, petunias, sweet potato vines, and ornamental grasses contrasts with the hard surfaces of the plaza.

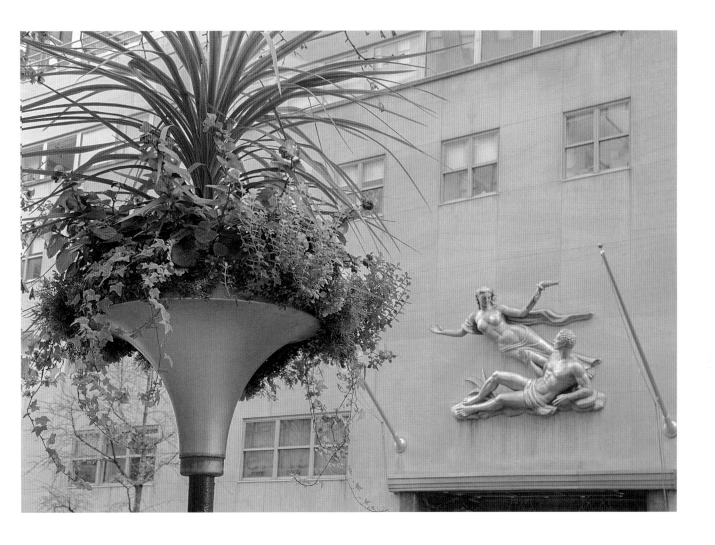

Above: An elevated brass-colored planter with dracaena, ivy, and begonias faces the modernist 980 Madison Avenue. Wheeler Williams's aluminum sculpture *Venus and Manhattan*, portraying "Venus awakening Manhattan to the importance of art from overseas," reflects the building's association with the fabled Parke-Bernet auction house and contemporary art galleries.

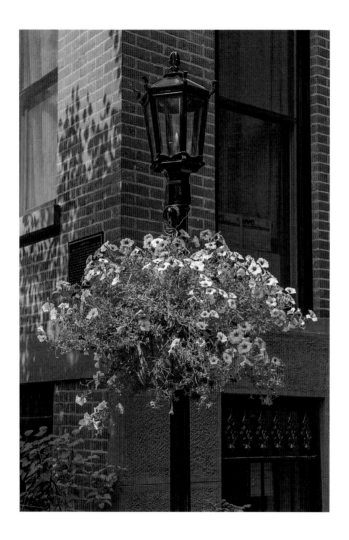

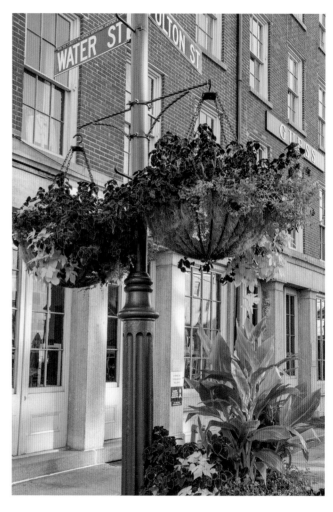

Above: A hanging planter on a sunny Brooklyn street thrives with a mix of pink and lavender petunias, while a pair of baskets for a partially shaded location on Water Street uses foliage plants—burgundy coleus and lime-green sweet potato vine—to provide color.

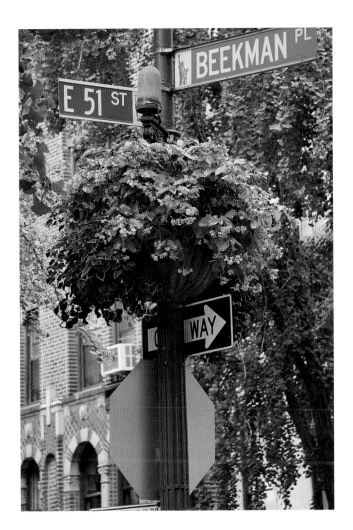

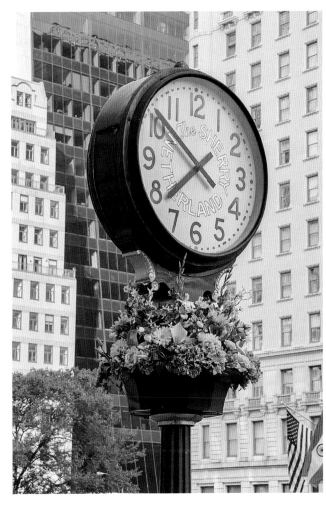

Above, left: A Beekman Place basket, positioned at a sunny intersection, holds a single variety of pink begonia that flowers continuously and trails gracefully over the edges of the pot.

Above, right: The Sherry Netherland Hotel clock on Fifth Avenue has a bright basket of artificial flowers below the face, drawing attention to the beautiful timepiece.

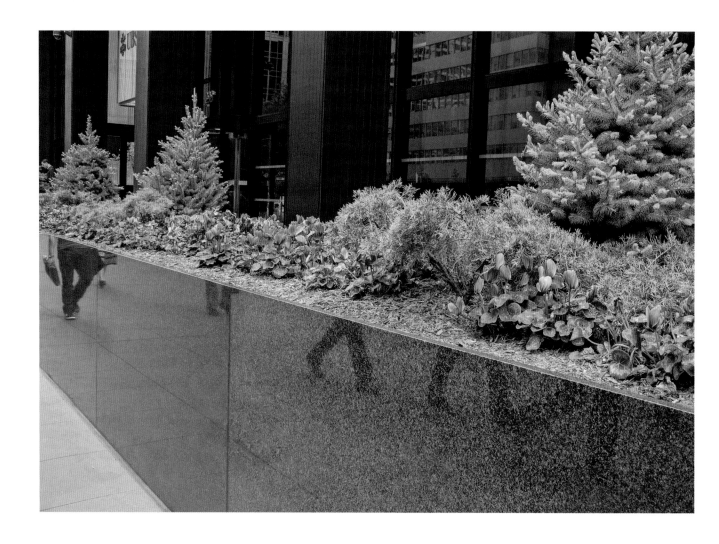

Above and opposite: Both of these low granite planters, positioned in front of buildings on Park Avenue, hold vivid plantings mixed with evergreen shrubs: bright-pink cyclamen and lime and burgundy coleus, red salvia, yellow marigolds above, and pink petunias opposite.

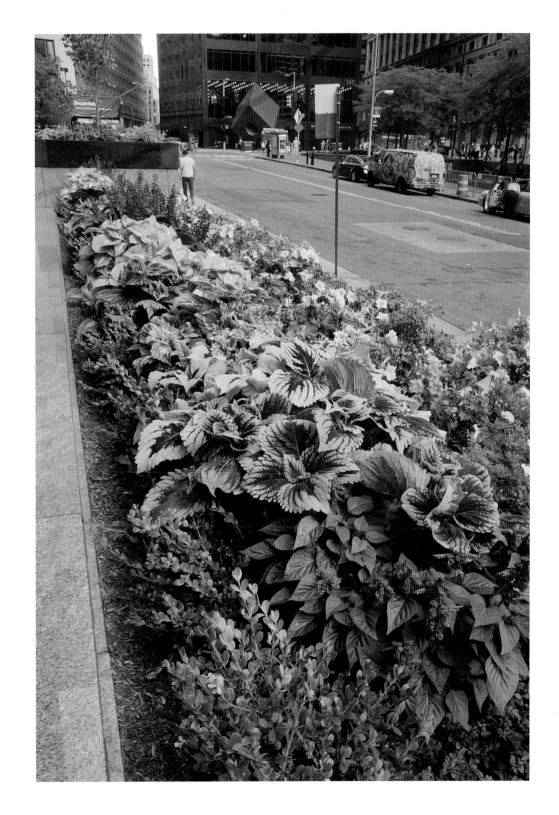

A raised median on Houston Street contains a stand of roses in full bloom. Carefree Wonder roses are hardy and resilient; they bloom heavily if given enough water. These are also clearly resistant to traffic fumes and heat. Oak trees and ivy complete this simple planting.

Urban Edens:
Plazas and Pocket Parks

Given the extreme density of the land use and the population of New York City, places of respite are an important amenity in a landscape dominated by hard pavement. Pocket parks and plazas in front of buildings with seating, plantings, and a water feature meet the need for a place to sit quietly, away from noise and congestion.

Pocket parks are often squeezed between commercial buildings and feature peace and greenery. One of the busiest—Paley Park—is steps away from a heavily traveled part of Fifth Avenue and succeeds in drowning out the noise of the city through a thundering waterfall spanning the entire back wall of the park. Other less elaborate pocket parks serve the same function of respite, quiet, and beauty.

The use of water in a plaza or park has a soothing, close to hypnotic effect on people who can take the time to sit nearby. The sound and sight of water as well as the cooling effect on the surrounding air make a fountain, waterfall, or pond with moving water enormously attractive.

Plazas in front of commercial buildings provide a great example of the blurring of public and private space. While officially belonging to a building and its occupants, some plazas become a destination for the public, especially if they offer shade, attractive plantings, and comfortable seating. The lively and benevolent use of a commercial plaza turns what could be a wasteland into a pleasant urban space.

The David H. Koch Plaza, designed by OLIN for the Metropolitan Museum of Art, features an allée of little-leaf linden trees on either side of the main entrance to the museum. This huge space —four blocks long—now has more than two hundred trees to shade the sun-drenched plaza. The gray granite paving, the trees, and the water of the fountains are the main design elements of this restrained yet welcoming space.

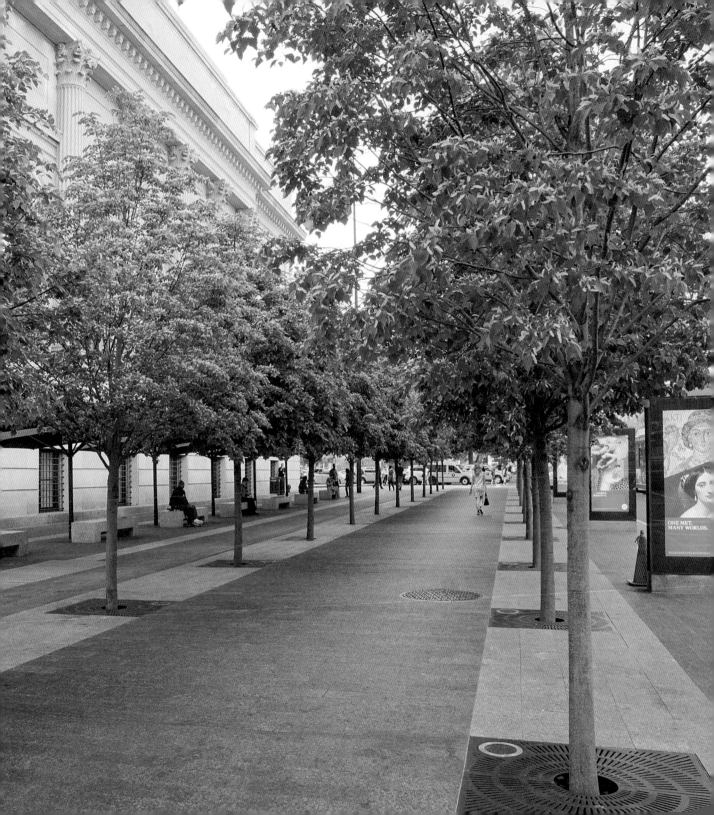

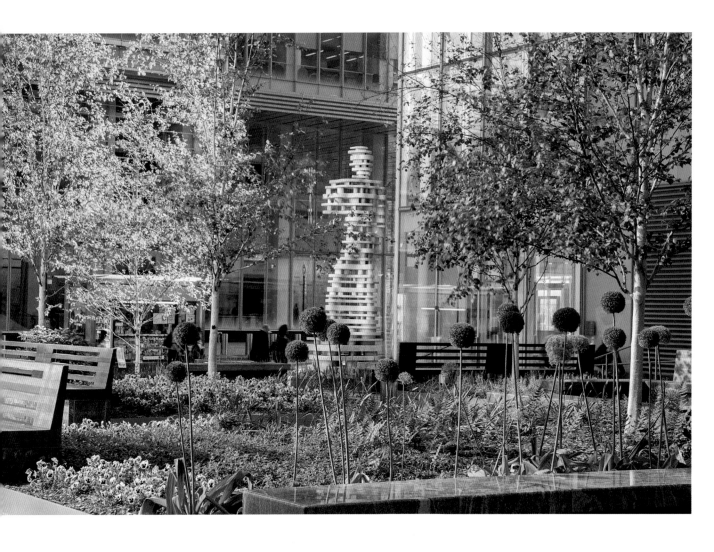

Above and opposite: Monumental sculpture enhances two public spaces in different parts of the city. *The Guardians: Hero and Superhero*, by Antonio Pio Saracino, is installed in Three Bryant Park Plaza, while 28 Liberty Street Plaza in Lower Manhattan features Jean Dubuffet's *Group of Four Trees*. Both spaces offer the amenities of flowering plants, shade, and seating that are critical for respite from urban clamor.

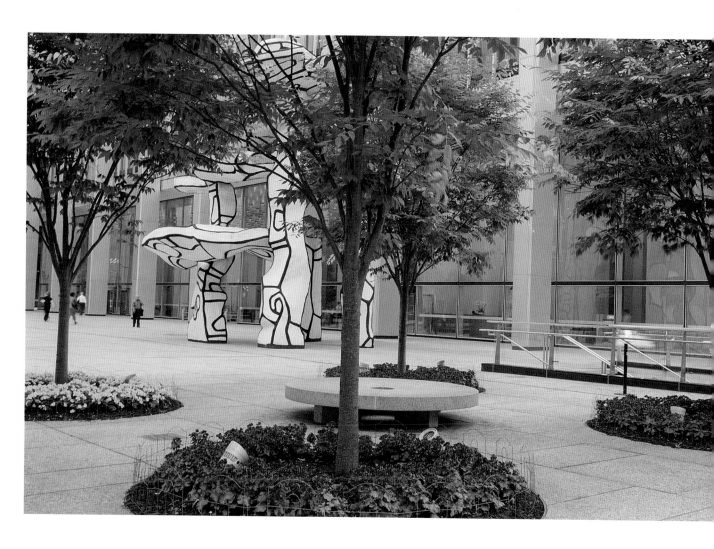

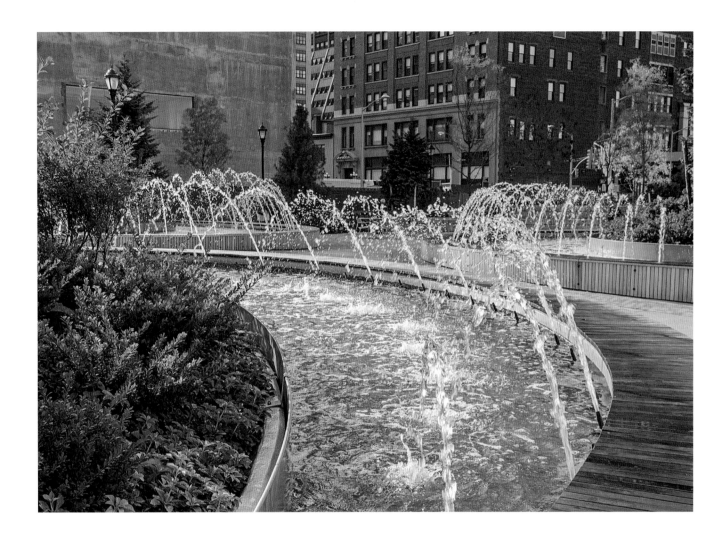

Above: Hudson Park and Boulevard was developed for the Hudson Yards neighborhood, which is transitioning from an industrial area to one of mixed land-use that's friendly to pedestrians. These fountains outside of the new Hudson Yards subway entrance anchor the landscape.

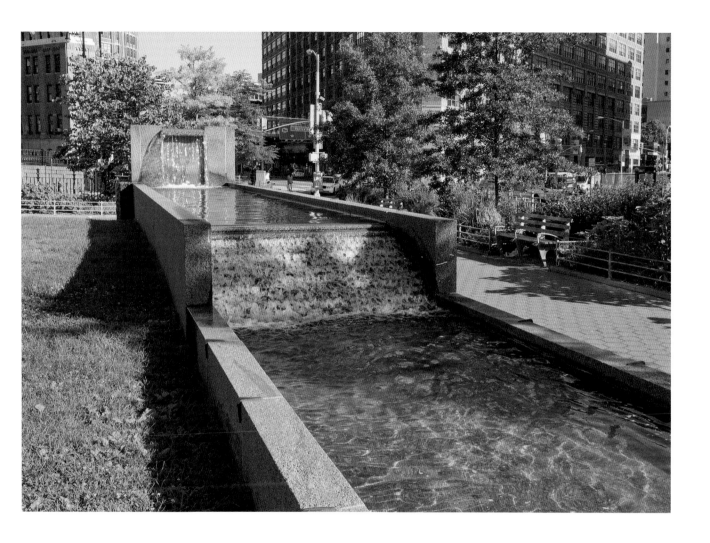

Above: Albert Capsuoto Park in Tribeca features a 131-foot fountain with waterfalls that mimic the flow of the canal with locks that used to run under Canal Street. Elyn Zimmerman's sculptural fountain complements the wide sidewalk, lawn, benches, and plantings that make this former parking lot a pleasant place to linger.

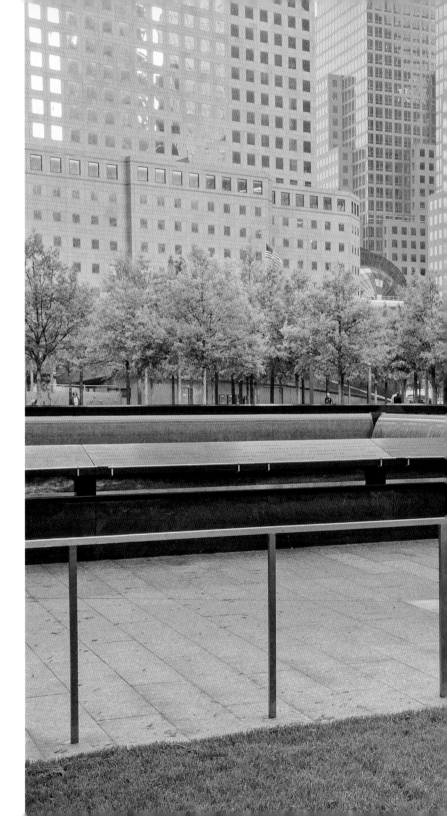

More than four hundred oaks
are planted on the plaza that
surrounds the 9/11 Memorial.
Designed by landscape architect
Peter Walker, the plaza serves as a
green roof for the museum below.
The beautiful groves of trees are
affirmations of life and rebirth.

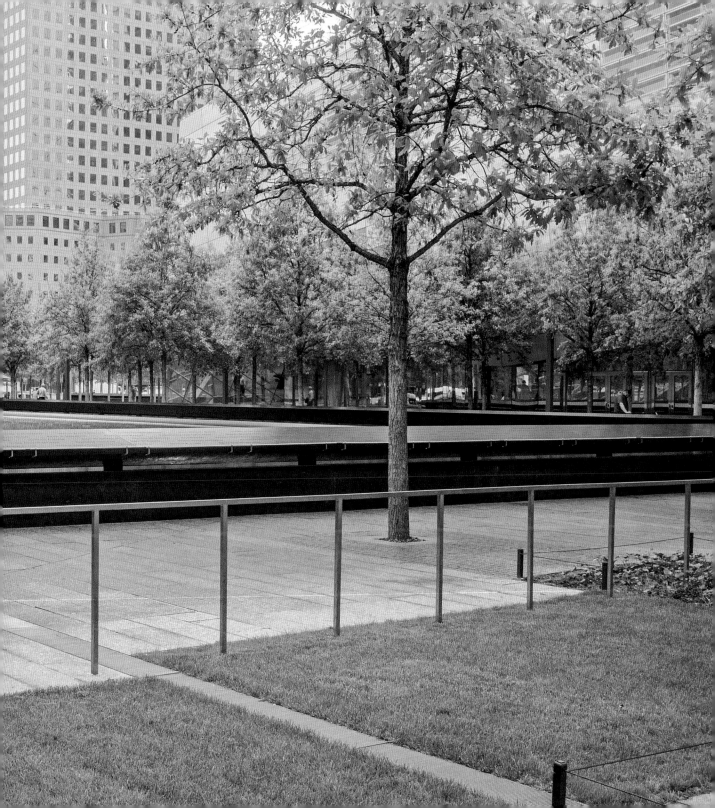

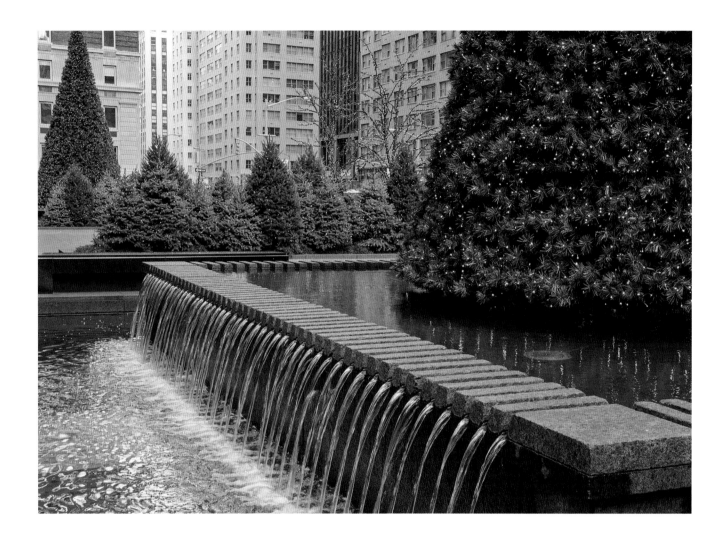

Above: Pools mark the corners of the AB AllianceBernstein building at 1345 Avenue of the Americas. For the holidays, evergreens with sparkling lights replace the tall "dandelion head" fountains.

Opposite: Christie's Sculpture Garden at 535 Madison Avenue provides water, seating, and shade and displays sculpture prior to sale at auction.

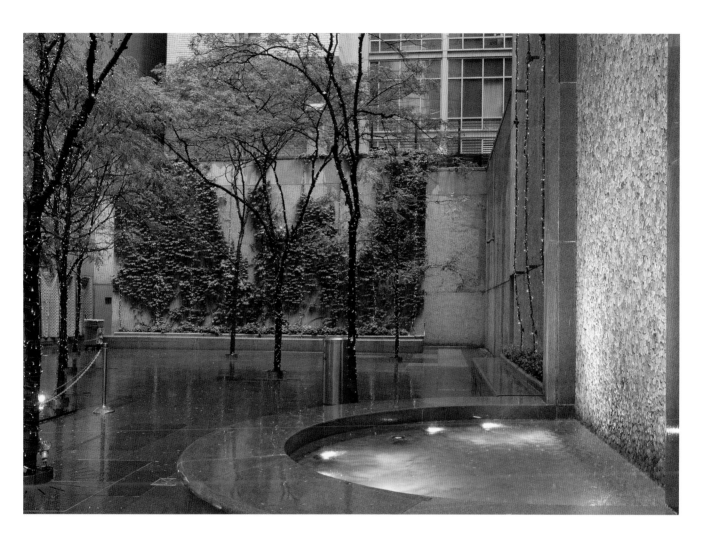

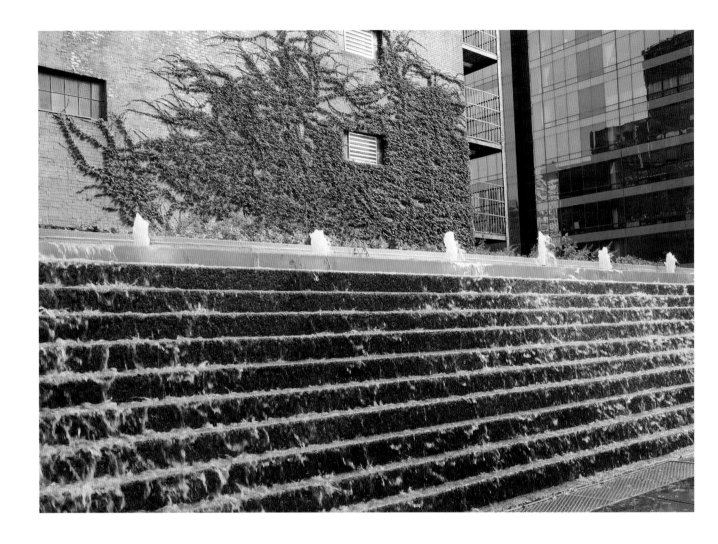

Above: This privately owned public space at the back of the property at 525 East 72nd Street features a staircase waterfall. Seasonal plantings, red maple trees for shade, and seating complete the pocket park.

Opposite: The through-block plaza behind 1221 Avenue of the Americas, designed by Specter DeSouza Architects, is divided by a two-sided water wall with a transparent acrylic tunnel that gives the sensation of walking through water.

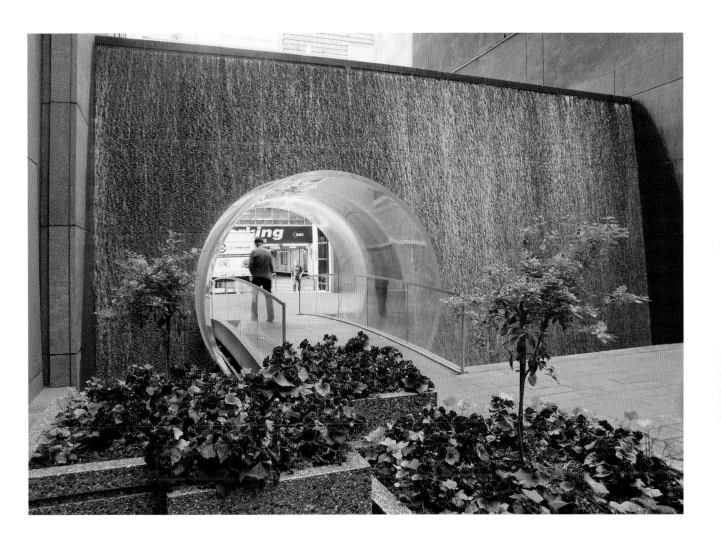

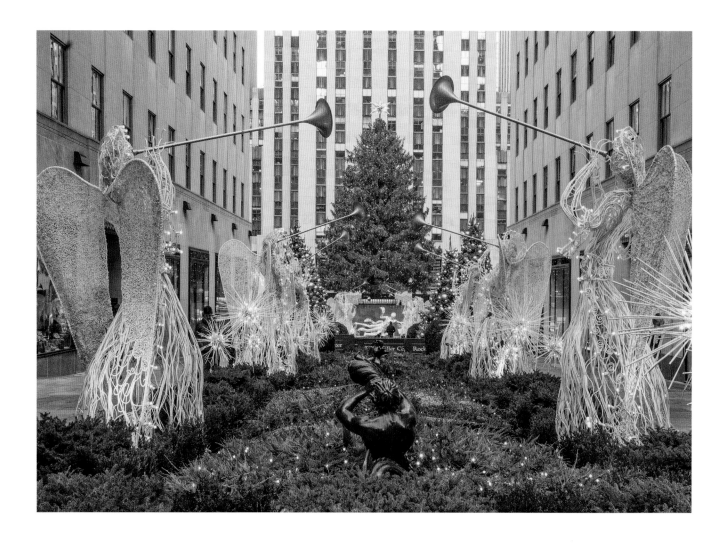

Above: The Channel Gardens at Rockefeller Center encompass a 200-foot walkway with six granite pools, several bronze fountains, and beds that are seasonally planted. Most beloved are the Christmas Angels that lead to a sunken plaza, with the iconic Rockefeller Center Christmas tree in the background. On the far wall of the plaza is Paul Manship's gilded-bronze statue of Prometheus.

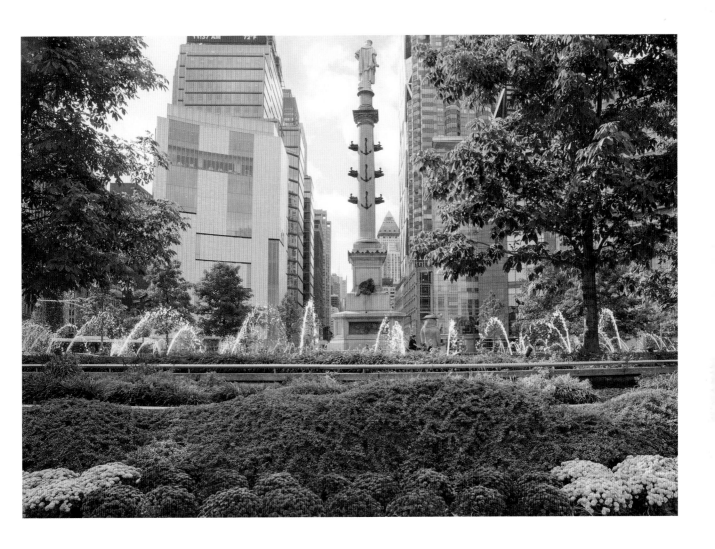

Above: The redesign of Columbus Circle by OLIN is based on concentric rings of vibrant plantings on the outer circle, a series of fountains, a ring of striking benches, and an inner circle of paving— all surrounding the monument to Columbus.

The Pulitzer Fountain, designed by Karl Bitter and topped with his sculpture of Pomona, goddess of abundance, is the centerpiece of the south section of Grand Army Plaza at Fifth Avenue and 59th Street. Tough plants that can do well in a very exposed location thrive here, including orange zinnias, yellow marigolds, and variegated leaf cannas with orange flowers. The arc of London plane trees around the fountain evokes the original design by Carrère and Hastings.

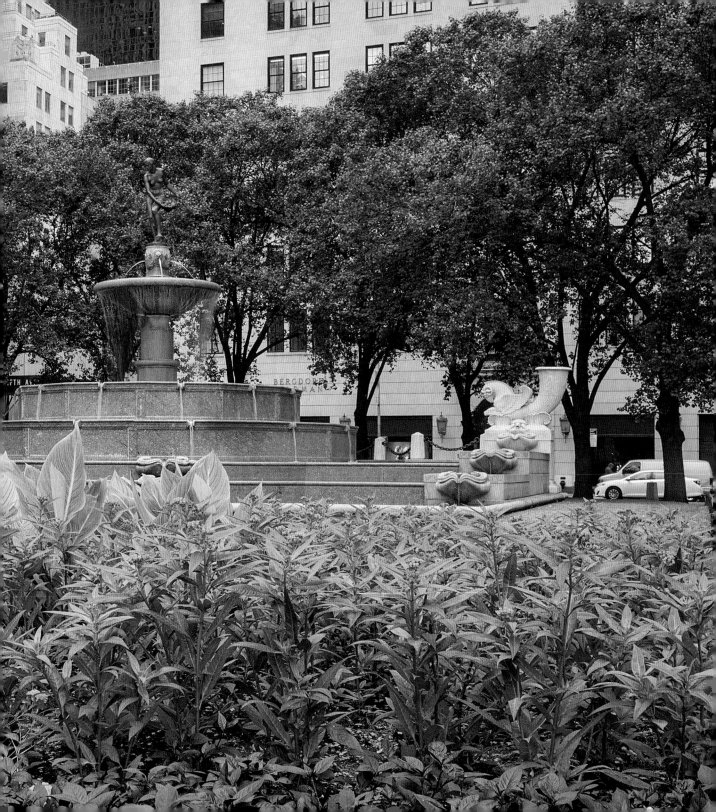

Above: The Broadway Mall Association has planted the entrance to the 96th Street subway station on the Upper West Side with a mix of roses, coral bells, day lilies, and grasses.

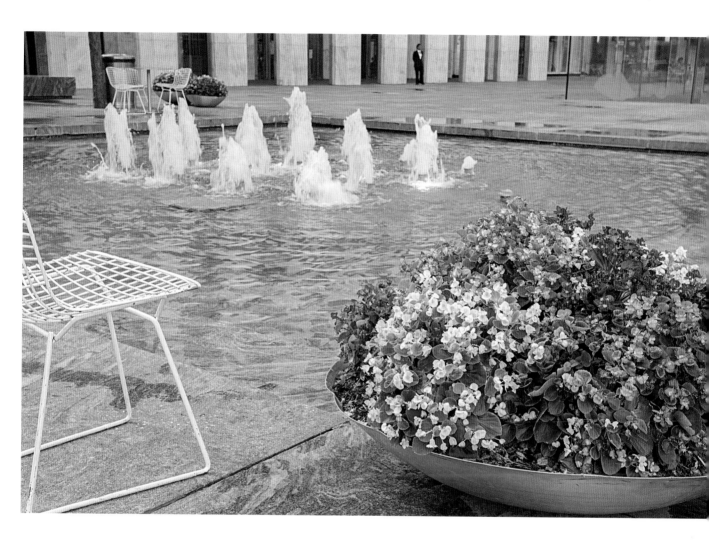

Above: The original sunken plaza in front of the General Motors Building on Fifth Avenue was redesigned by Moed de Armas & Shannon as a welcoming street-level space with two pools, flexible seating, and low bowls filled with a mix of wax begonias. The plaza houses the iconic glass cube of the Apple store.

Paley Park, the city's first pocket park, was designed by landscape architects Zion & Breen for a space between commercial buildings on East 53rd Street close to bustling Fifth Avenue. The 20-foot-high waterfall spans the entire back wall of the park and creates sound that drowns out the noises of the city. Calm and intimate, the design is simple, with ivy-covered walls and a canopy of honey locust trees that allows sunlight to filter in.

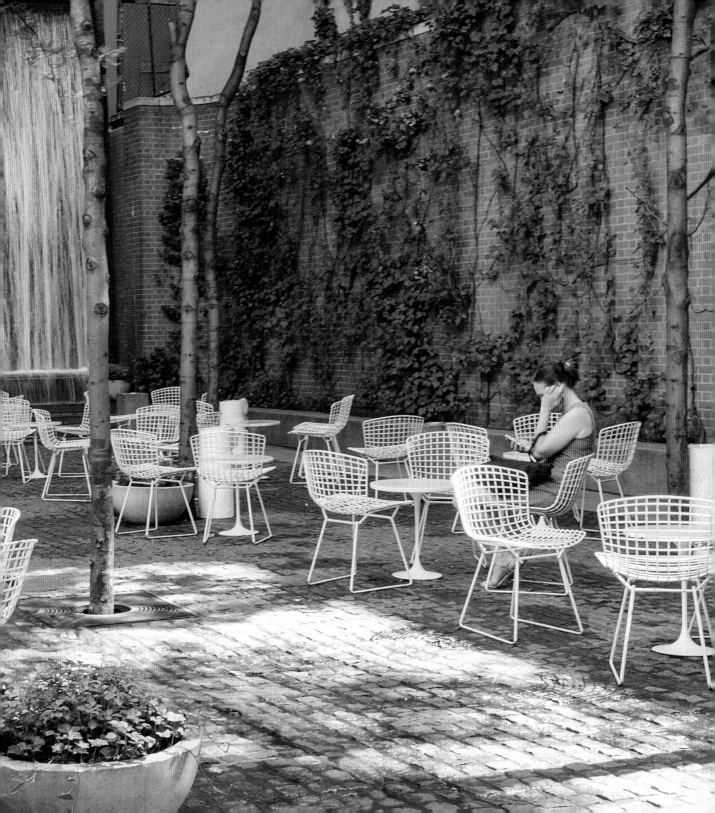

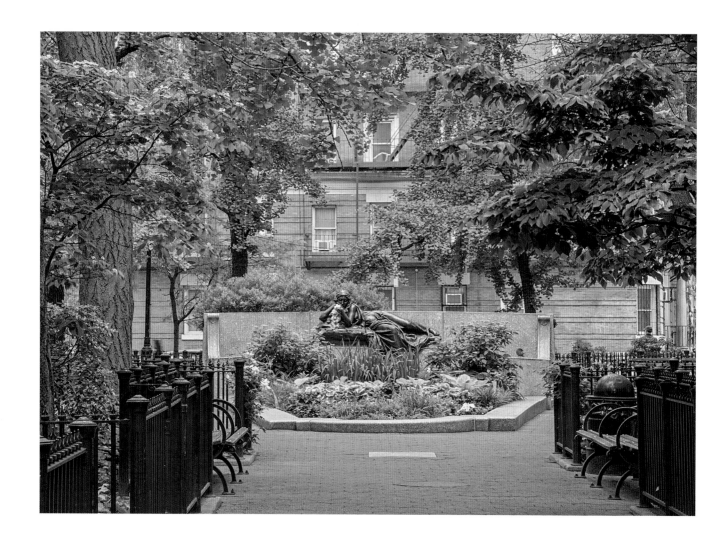

Above: Straus Park commemorates Ida and Isadore Straus, who refused to be separated as the *Titanic* sunk. This green oasis, on a triangle bounded by West 106th Street, Broadway, and West End Avenue, features Augustus Lukeman's bronze sculpture, *Memory*.

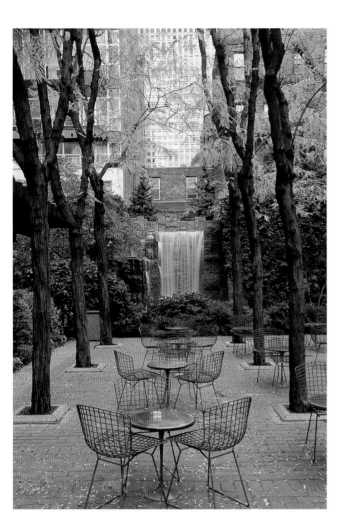

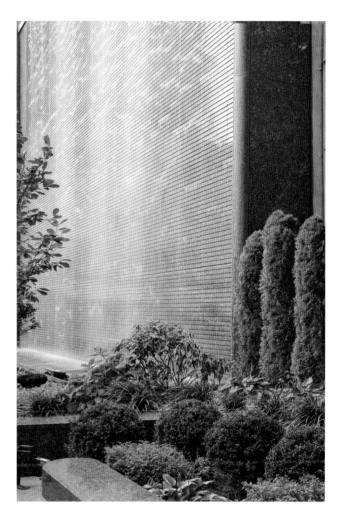

Above, left: A dramatic waterfall that cascades over granite ledges is the focus of Greenacre Park, a secluded space nestled between buildings on East 51st Street with multiple levels, cafe seating, trees, and seasonal plantings.

Above, right: A wall of water at the entrance to Trump Plaza in the East 60s needs only green foliage and a low granite wall to be a place of tranquility.

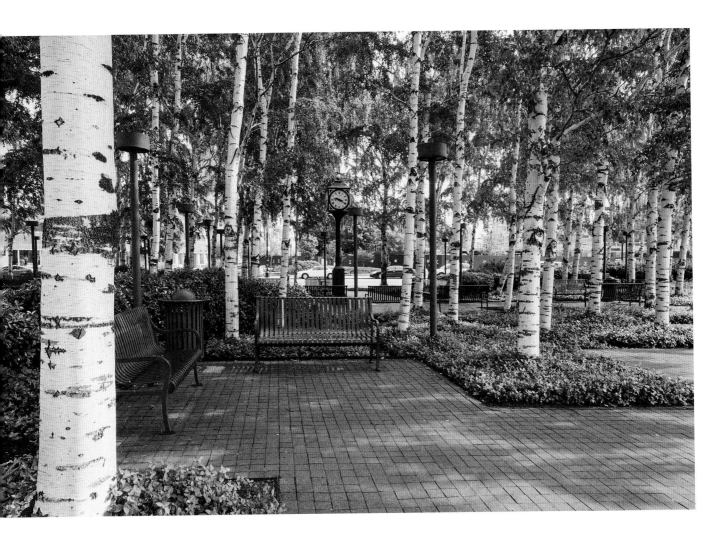

Above: The plaza of Citigroup's One Court Square is planted with three stands of paper birch trees. Benches are nestled among seventy-five trees underplanted with ivy.

Opposite: Next to the French Embassy's cultural services office on Fifth Avenue and 78th Street is the Florence Gould Garden. The river birch trees have peeling bark that exposes buff-colored new bark that whitens as it ages and brightens the shaded space.

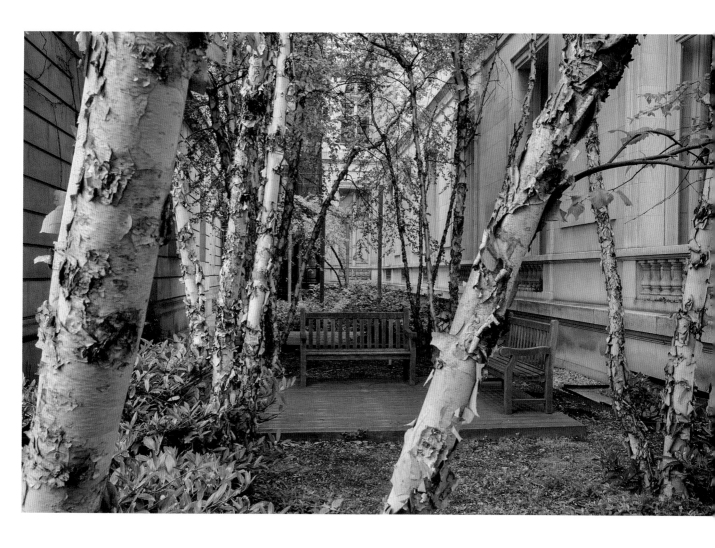

Overleaf: This pristine lawn and planting beds, with a mix of bright spring tulips, is part of Abingdon Square Park in the West Village. Maintained by the Abingdon Square Conservancy in cooperation with the Parks Department, the park is one of the oldest in the city. The land was acquired by the city in 1831, and Calvert Vaux and Samuel Parsons Jr. laid out the park in the late 1880s.

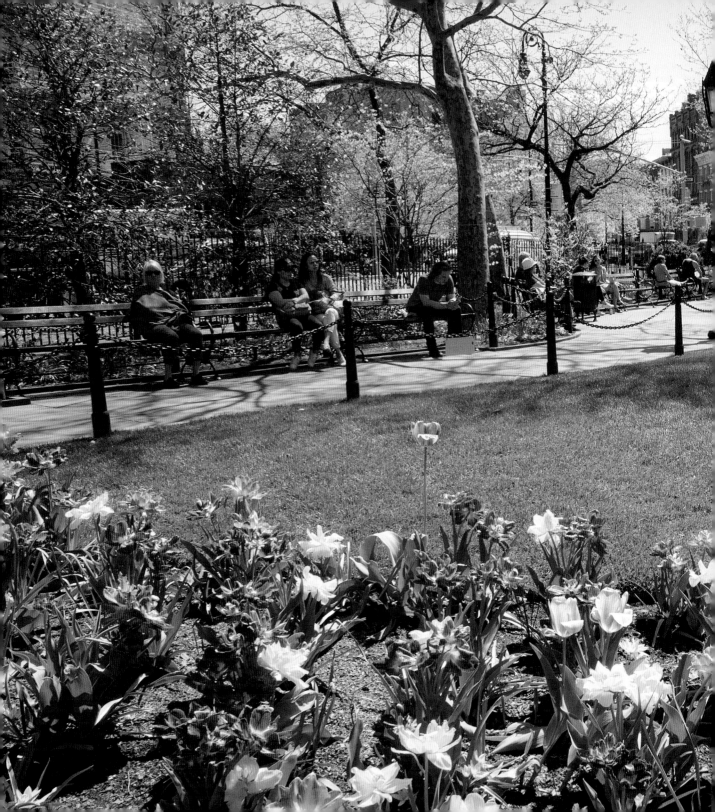

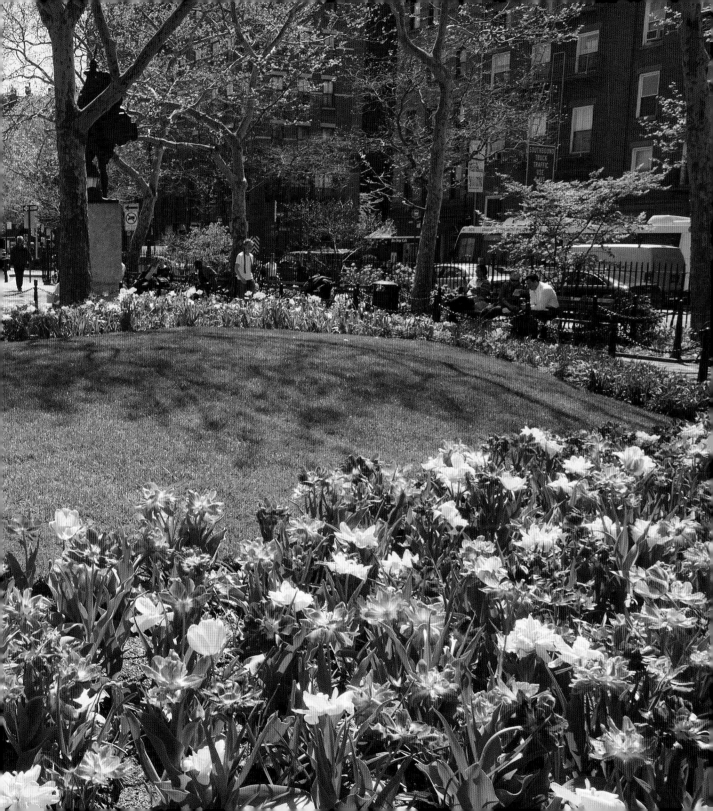

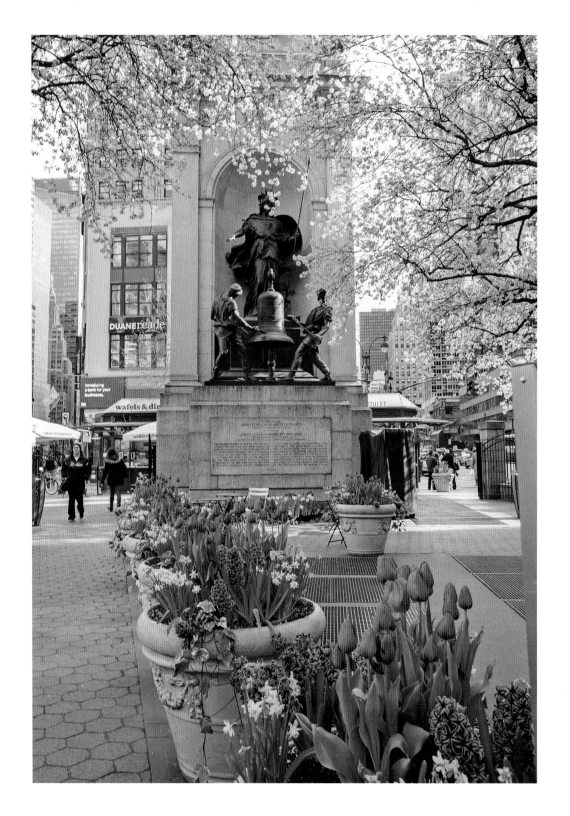

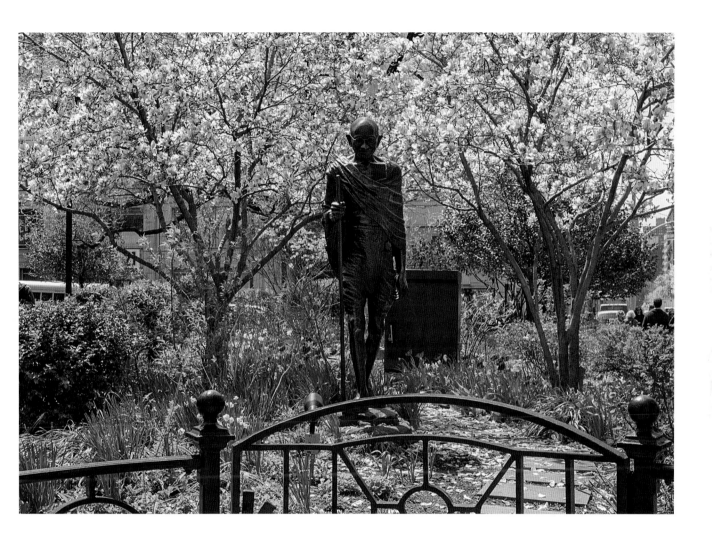

Opposite: Herald Square is a well-used pedestrian plaza with seasonally planted pots, seating, and a canopy of flowering Callery pear trees. The spring plantings include daffodils, hyacinths, tulips, and ivy. The James Gordon Bennett monument commemorates the founder of the *New York Herald*, whose headquarters, designed by McKim, Mead & White, once stood on the site.

Above: A small triangular garden at the southwest corner of Union Square houses a beloved statue of Mahatma Gandhi, often clothed with flower garlands in the summer, and scarves and a hat in the winter. The flowering cherry trees, magnolias, tulips, and daffodils are followed by a variety of perennials and shrubs, anchoring this end of the park with an unexpected garden.

65

Lafayette Square in Morningside Heights features a simple planting of sycamore, Callery pear trees, and variegated ground cover. French sculptor Frederic-Auguste Bartholdi, creator of the Statue of Liberty, designed the monument, *Lafayette and Washington*.

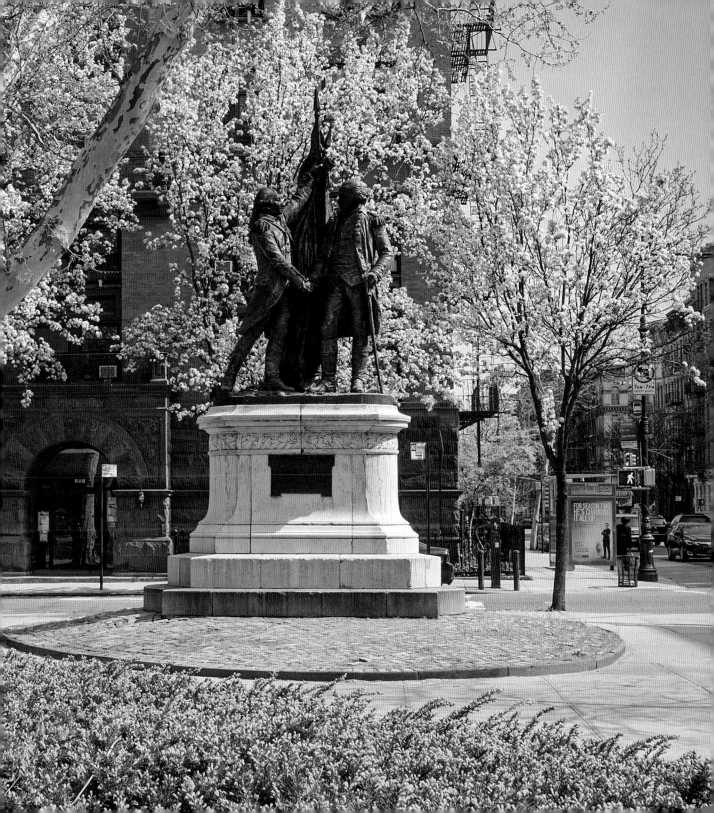

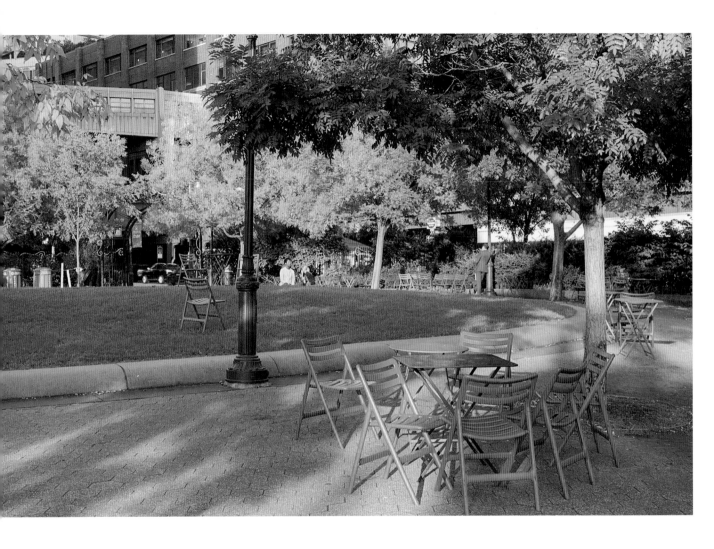

Above and opposite: Flexible seating in vivid colors—orange and lime green—is reminiscent of what's used in European parks, and the colors stand out against the deeper greens of the foliage. The lime-green lounge chairs and umbrellas are on Freeman Plaza East on Hudson Square and the orange chairs are in Hudson River Park in Chelsea.

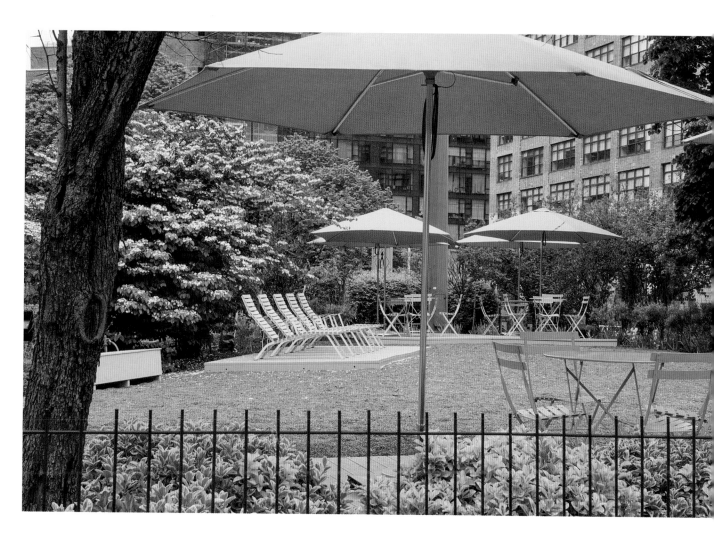

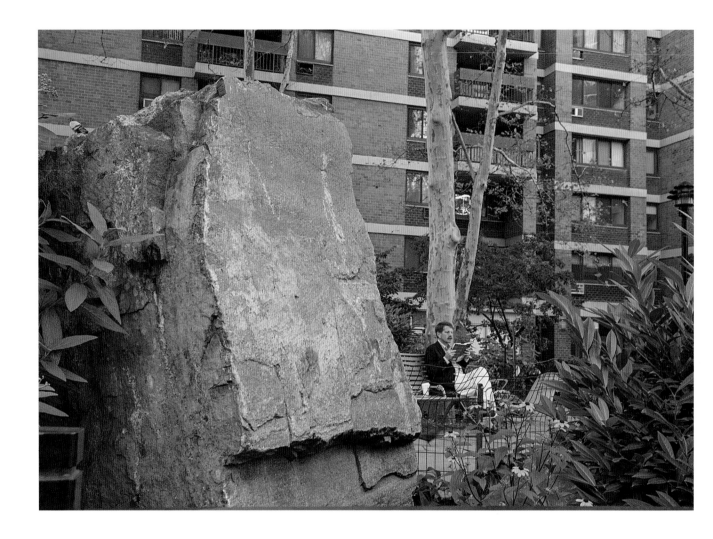

Above: Pocket parks can be carved out of small pieces of land, sometimes in the middle of traffic. DeLury Square on Fulton Street in Lower Manhattan was created by reconfiguring a dangerous intersection and adding land acquired from the adjacent Southbridge Towers.

Opposite: In East Harlem a block-long park, a project of Carnegie Hill Neighbors and designed by Lynden B. Miller with low-maintenance shrubs and four-season interest, replaced a neglected lot in the middle of Park Avenue at 97th Street.

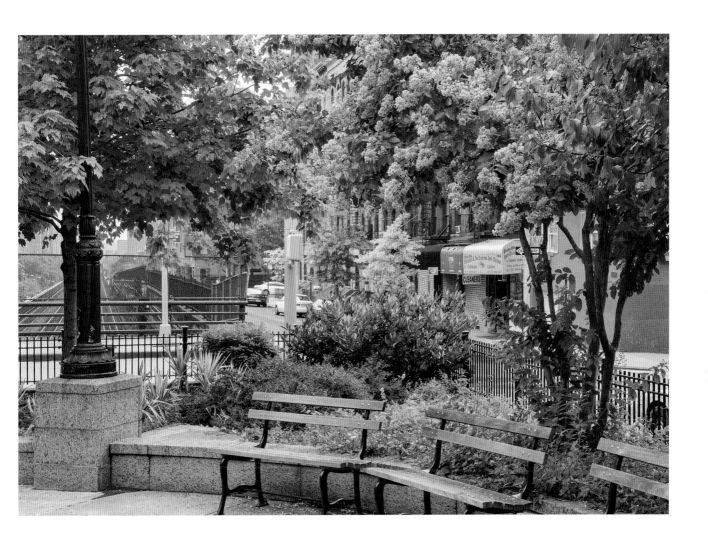

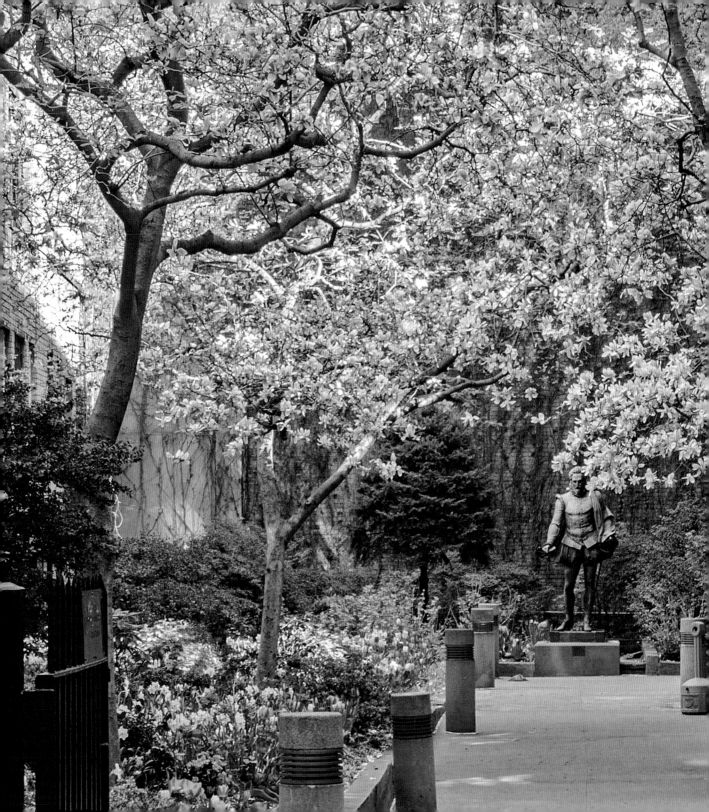

Willy's Garden, the entrance to the NYU School of Arts and Science at Washington Square North, features a statue of Cervantes at the end of a walkway bordered by beautiful spring plantings. A canopy of magnolia trees arches over the abundant spring bulbs.

Urban Front Yards
Inviting and Inspiring Spaces

Take a walk through any of the city's residential neighborhoods and you'll see a wealth of planted window boxes, urns, and pots around doors and stairways, and landscaped courtyards in front of townhouses and apartment buildings. Gardens have been expanded from private spaces hidden from the street—backyards, terraces, and roof gardens—to those in front of the building that can be seen and enjoyed by passersby. There's ever-greater creativity being applied to these front gardens by garden designers, landscape architects, and homeowners, and plantings near the building are often complemented by those in nearby tree beds.

Restaurants, small businesses, hotels, places of worship, schools, and other institutions use the front of their buildings to add plantings to delight patrons and the public. Their facades are more welcoming, and in many cases, the plantings help to make the entrances more obvious. Restaurants with sidewalk dining tables often delineate the seating area and provide psychological distance from the street with seasonal plantings.

A number of developments have led to the use of space in front of residential and commercial buildings for gardening, including increasing support for a beautiful and greener environment as well as the decline of lifestyle crimes, making it safer for people to invest in plantings on the street. The growth of gardening as a leisure pursuit and the related growth of plant varieties and sources have led to a broader palette of plants beyond the traditional triumvirate of begonias, geraniums, and mums that can be used successfully in the harsh conditions of a city. The result is unexpected beauty.

Red tulips bordered by boxwood present an expressive spring display in front of a Fifth Avenue apartment building.

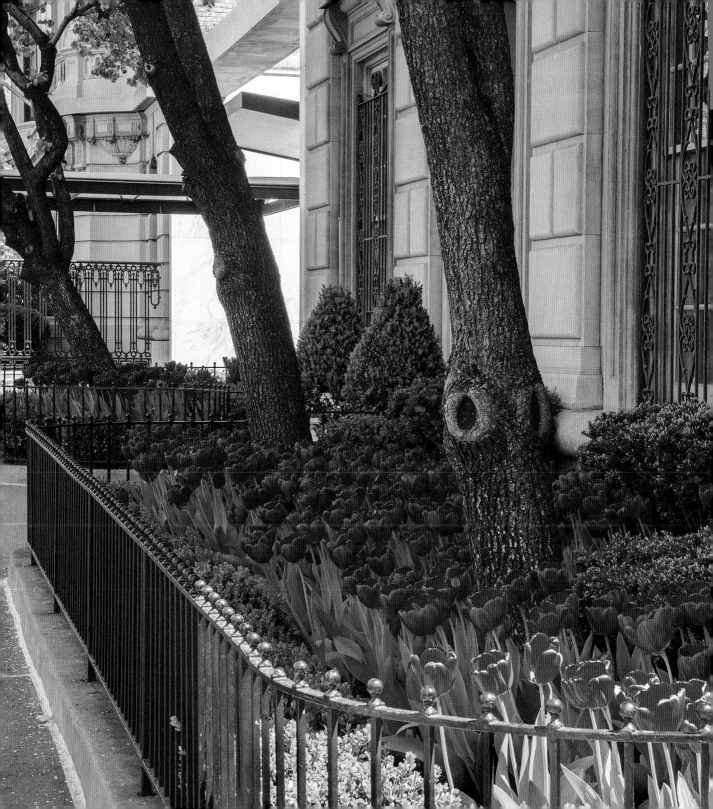

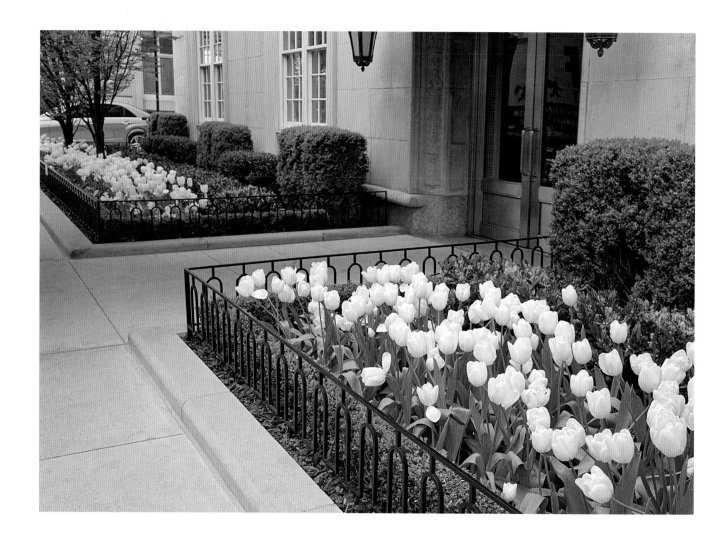

Above and opposite: A quiet planting of dark-green yews with pristine white tulips, edged with boxwood, lights up the entrance of an apartment building on Fifth Avenue while a narrower planting bed in front of another residential building incorporates a Japanese maple, rhododendrons, and variegated ivy.

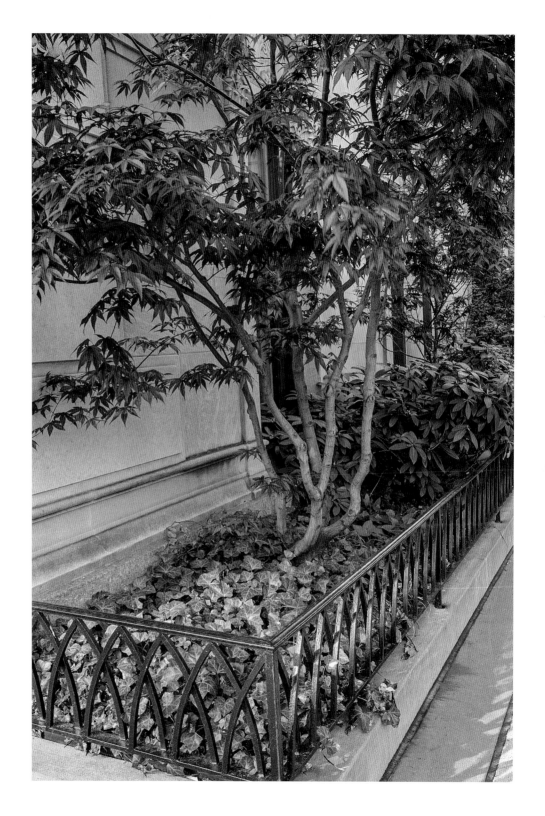

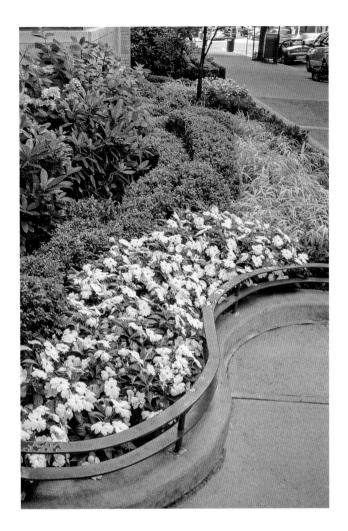

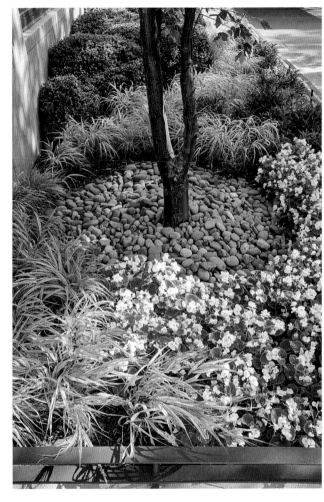

Above and opposite: Simple and restrained treatments for the front gardens of prewar apartment buildings make effective use of a limited palette, with three key colors: white, lime green, and dark green. Plants include rhododendron, boxwood, white flowering hydrangea, impatiens, a variegated plantain lily, and Japanese feather grass.

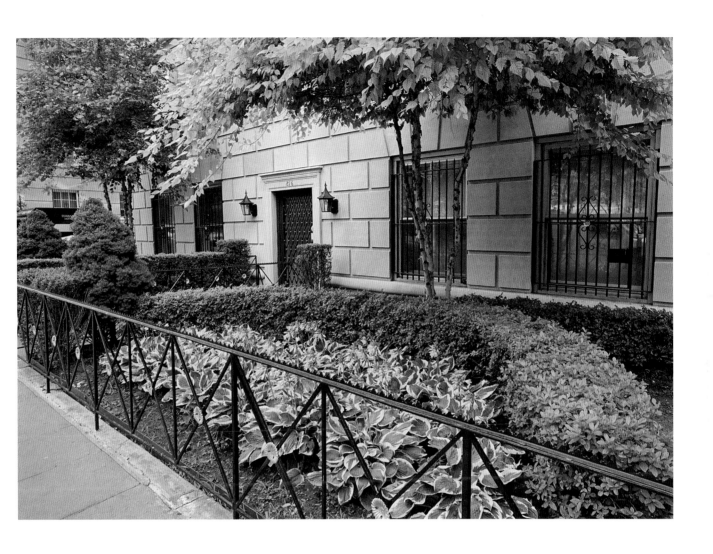

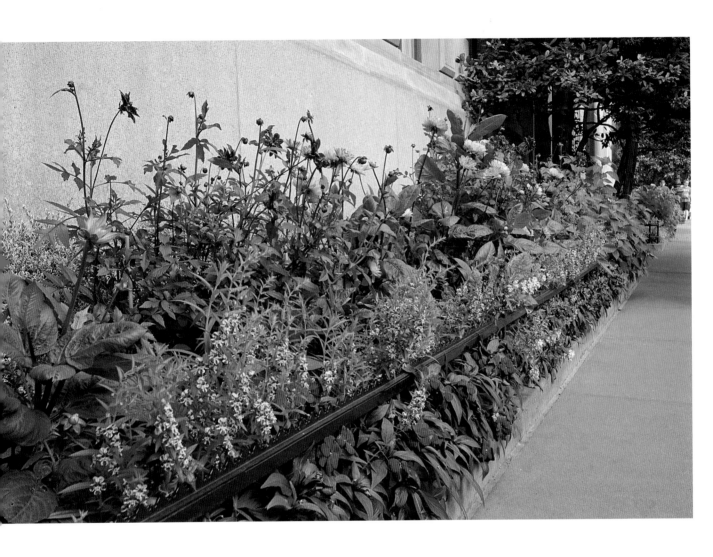

Above: This garden on Central Park West, designed by Jane Gill, feels like a country flower garden. Bright annuals—dahlias, angelonia, and New Guinea impatiens—spill out of the narrow planting bed.

Opposite: In Chelsea, burgundy barberry and purple-leafed plum trees, as well as green boxwood and a Hinoki cypress, carry color throughout the year. Pale pink New Guinea impatiens and other annuals in pink shades add summer color.

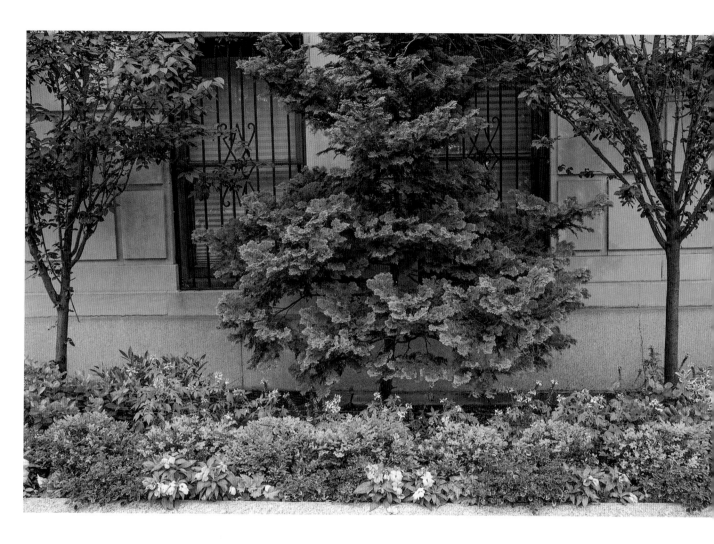

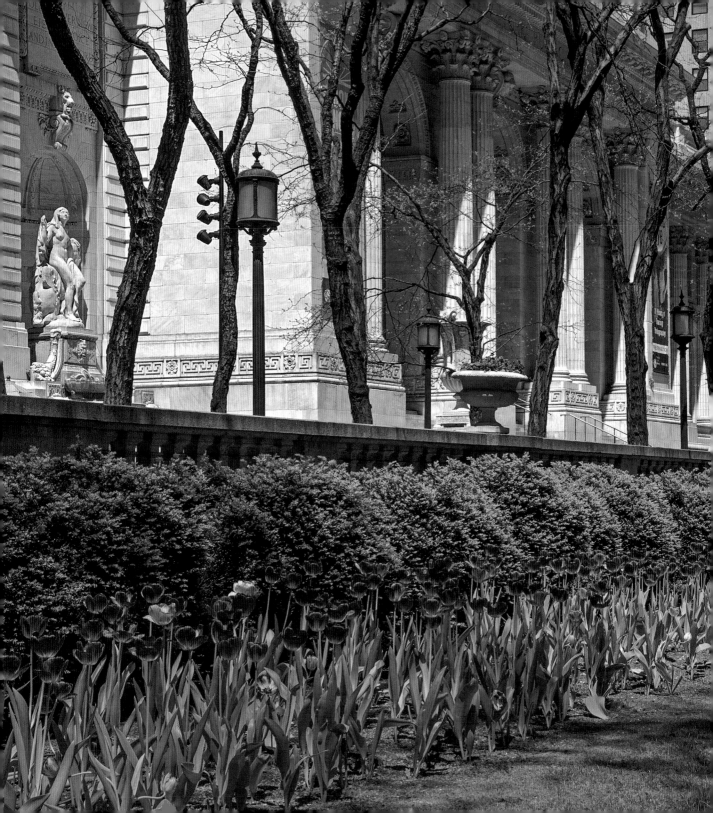

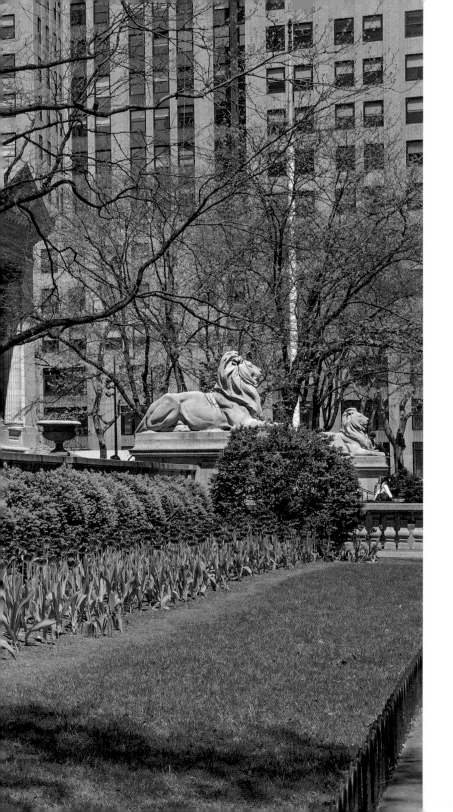

At the New York Public Library, beds flanking the entrance feature boxwood, yew, and a pristine lawn enhanced with Orange Queen tulips. Landscape designer Maureen Hackett designed the simple but formal planting to complement the Beaux-Arts architecture of the library.

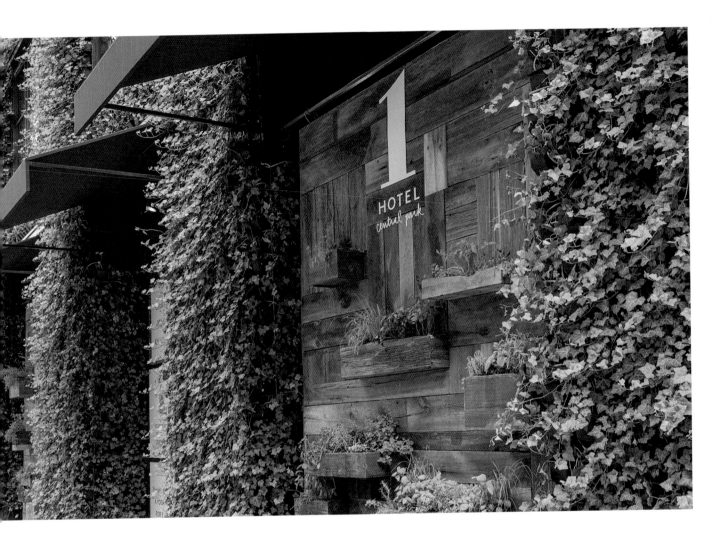

Above: 1 Hotel Central Park, at 58th Street and Avenue of the Americas, relies on plants inside and outside to create a tranquil environment, consistent with the theme of "being close to nature." The entrance features green walls clothed with evergreen ivy and small planter boxes with herbs on the wall.

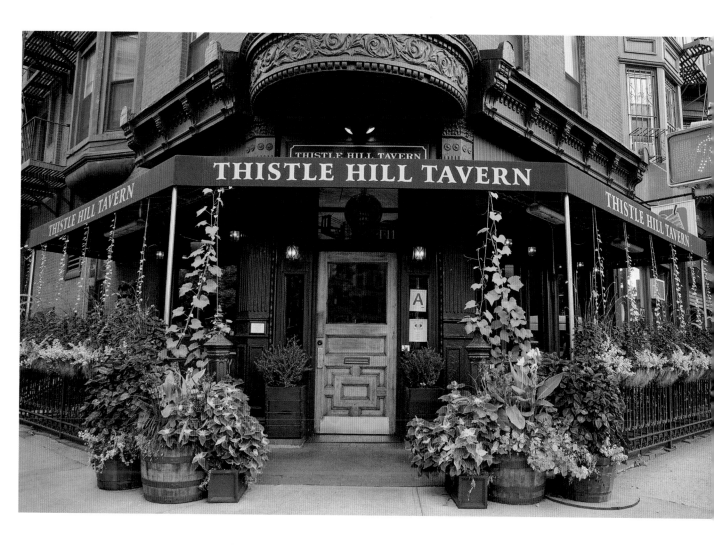

Above: Flowers and foliage at the Thistle Hill Tavern in Brooklyn welcome diners with colorful pots and climbing vines at the entrance and densely planted containers in the outdoor seating areas. The plantings, designed by Thomas Little of Urban Green, provide a sense of enclosure and create distance from the sidewalk traffic.

Above: Large planter boxes at the Little Prince restaurant's sidewalk seating area in SoHo create a barrier to the traffic and delight diners with bright geraniums and begonias.

Opposite: At the entrance to Brooklyn's River Café, a profusion of chrysanthemums and pumpkins create an effective autumn container garden. Evergreen shrubs provide a foliage backdrop through the year.

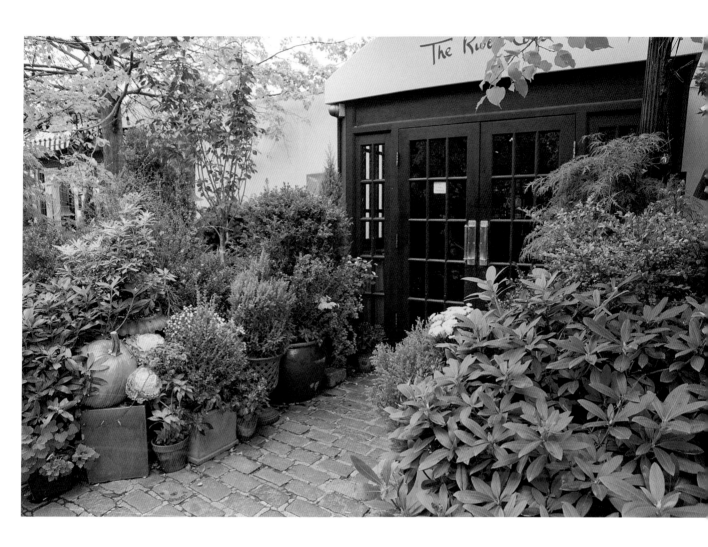

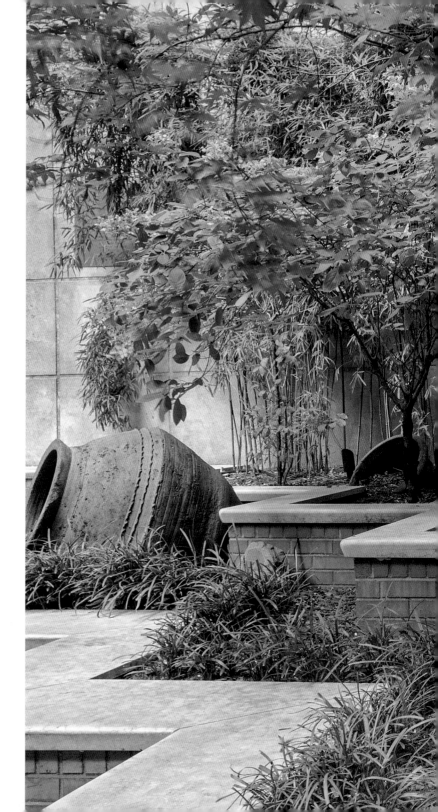

These large terra-cotta Cretan urns in a courtyard set back from the sidewalk on East 48th Street were imported by the adjoining restaurant, Avra Estatorio. Lily turf provides a green fringe next to the sidewalk, and a canopy of small trees and shrubs arches over the urns.

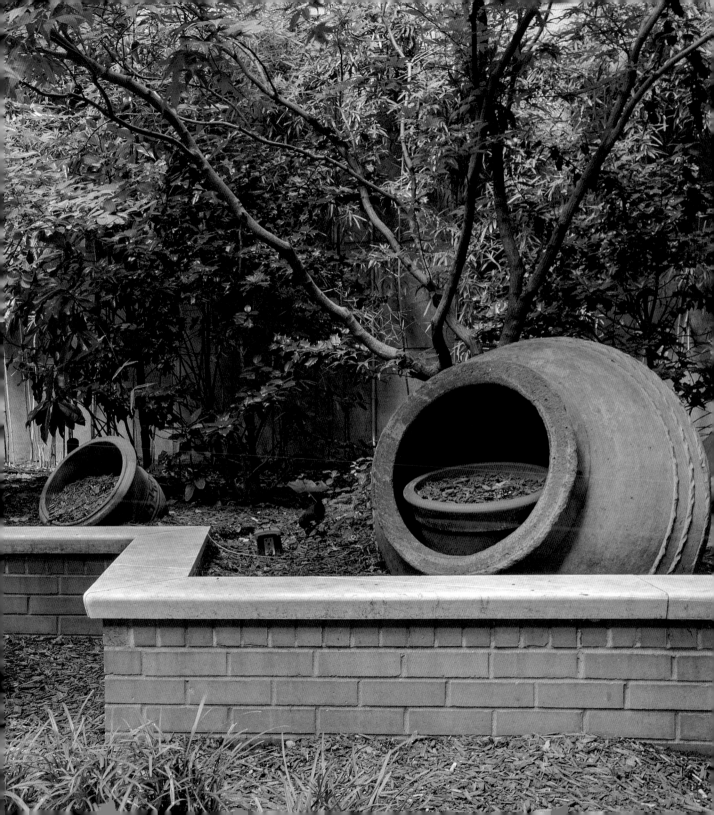

Above: In the courtyard of the Villard Houses, decorative metal containers hold small trees and topiary evergreens underplanted with seasonal flora.

Opposite: A ground-level mass planting of boxwood with a large Japanese maple, designed by Ken Smith Landscape Architect, provides drama and softness in the Lever House courtyard.

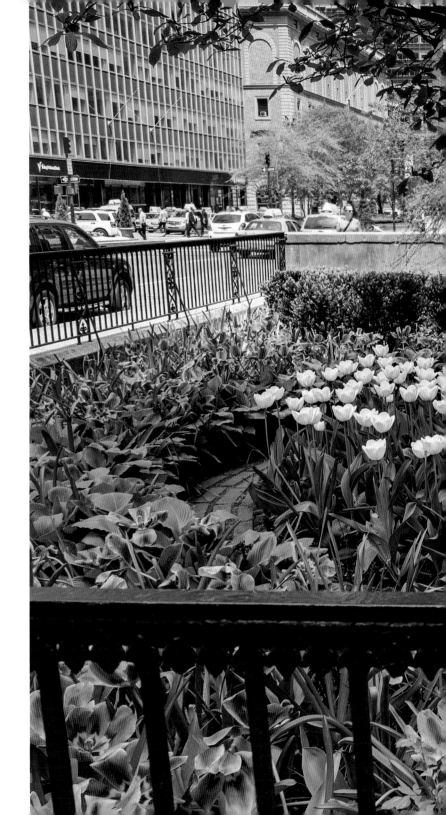

The Sallie Franklin Cheatham Memorial Garden in front of St. Bartholomew's Church on Park Avenue features a circular planting bed, with a magnolia at its center. The garden is at its best in the spring when it's bursting with tulips. The overall effect is one of a country garden dropped into the middle of the city, perfect for a space intended as a meditation garden.

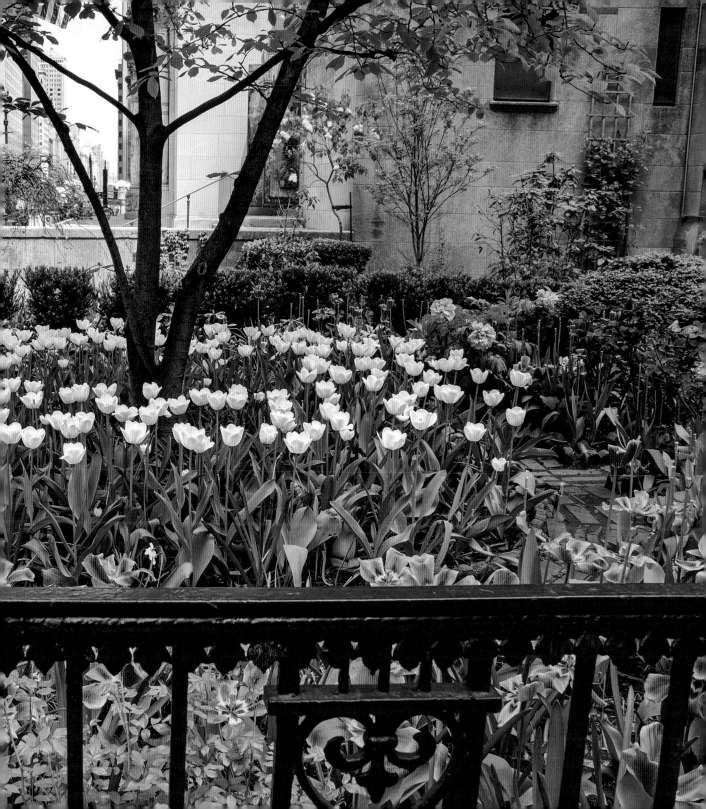

Above: Spring windows at Saks Fifth Avenue are filled with flowers and framed with box-wood; topiary trees and planter boxes of bright-green boxwood balls line the sidewalk.

Opposite: 583 Park Avenue, an event space in a neo-Georgian building designed by Delano & Aldrich, decorates the entrance porch with a line of urns with spiral topiaries juxtaposed with classical columns.

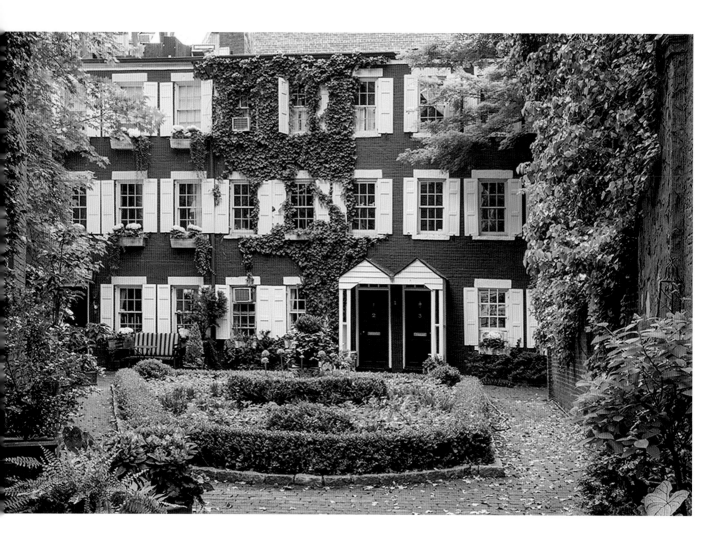

Above: Grove Court, a cluster of pre-Civil War townhouses, is a private enclave in Greenwich Village. Entrance is through an iron gate to a courtyard with a boxwood-enclosed circular planting bed. Ivy grows up the facades of some of the houses, adding to the serenity of this secluded spot.

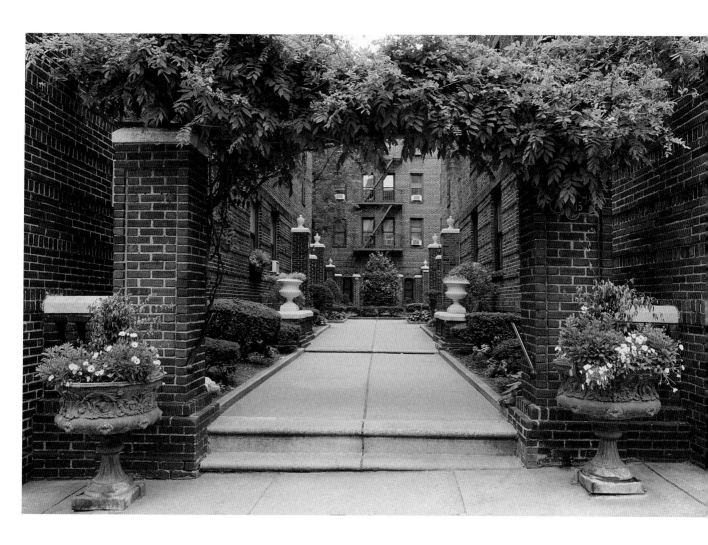

Above: This elegant courtyard entrance to an apartment complex in the Sunnyside Gardens Historic District in Sunnyside, Queens, uses urns with white plants and a canopy of wisteria vines to set a tranquil mood.

White urns and finials capping brick columns brighten the shady courtyard, and green yews and boxwood line the narrow planting beds.

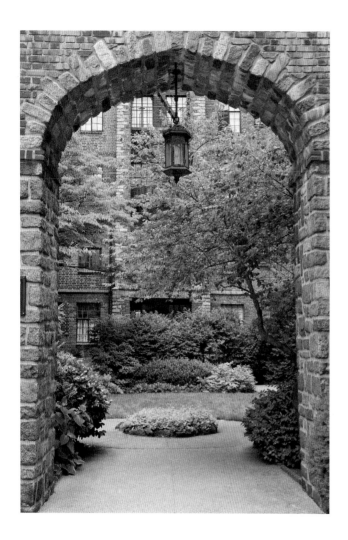

Above, left: Hudson View Gardens, a cooperative complex in Washington Heights, was designed in the 1920s to resemble a medieval English village. Stone archways lead from the street to interior gardens that fill about half of the four-acre site.

Above, right: The wooden arbor supports a profusion of pink Ballerina roses leading to a front yard garden in a residence across from Cooper Park in Williamsburg.

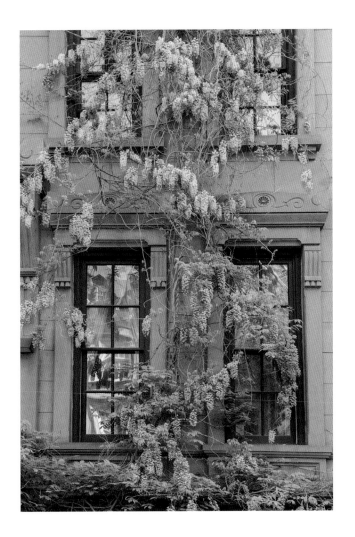

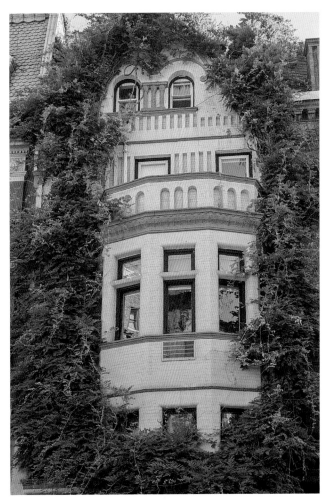

Above, left: The delicate lavender blooms of wisteria cover the front of a townhouse on East 74th Street. The flowers emerge before the leaves.

Above, right: A townhouse on West 81st Street is encircled by vigorous wisteria vines that have been trained around the facade.

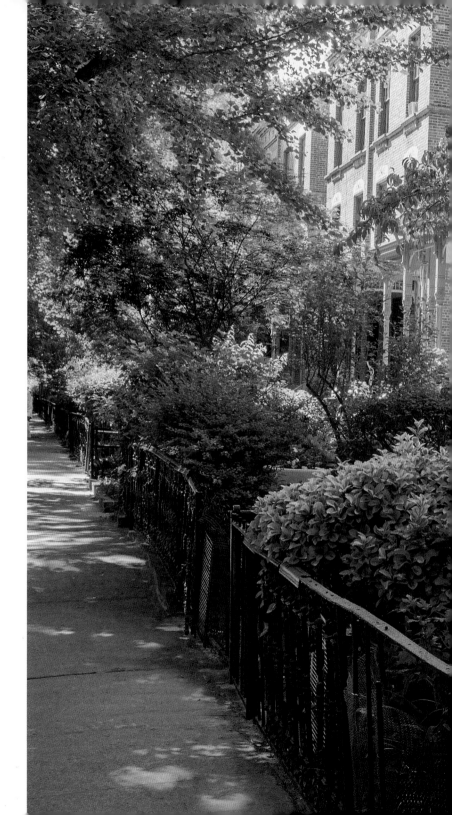

Generous front-yard gardens with wrought-iron fences enhance East 130th Street in Harlem. Wide steps, shallow porches, the shade canopy of the street trees, and a variety of shrubs, ornamental trees, and roses all add to the feeling of friendliness and comfort.

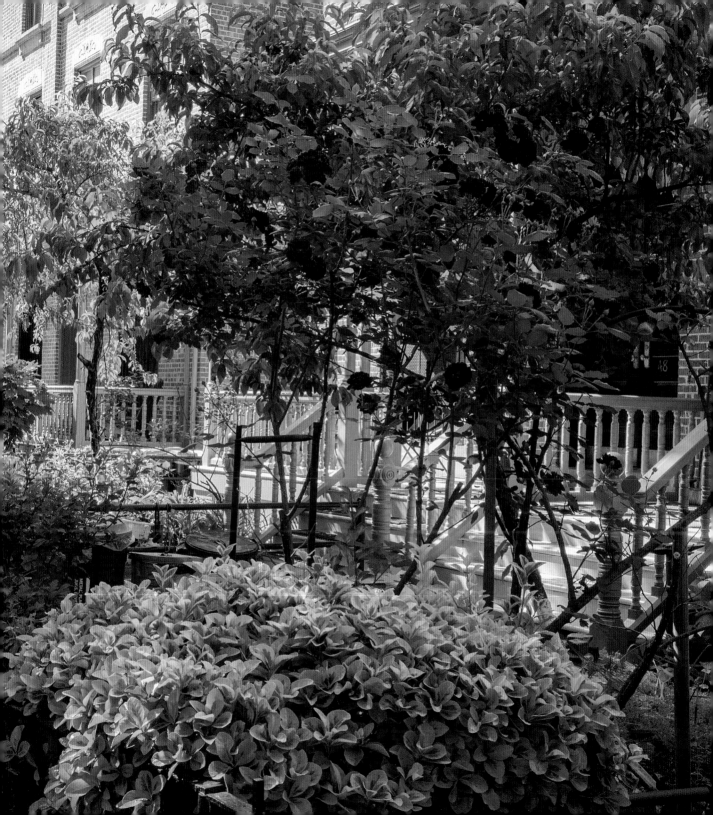

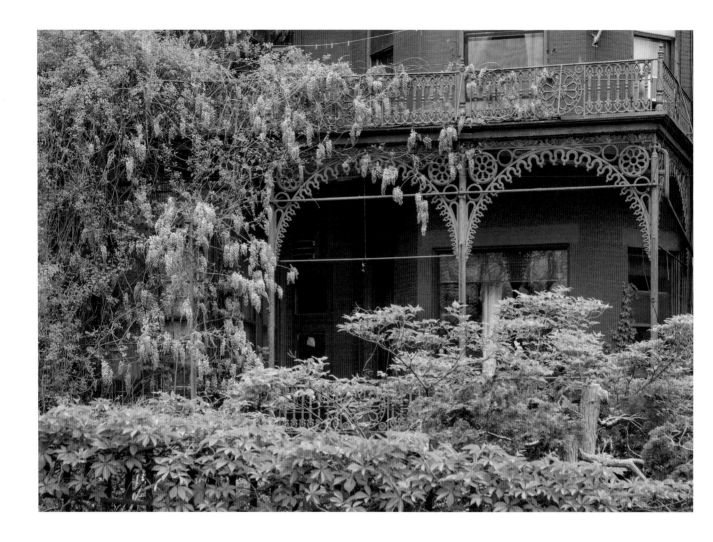

Above: In a rear yard along the Promenade in Brooklyn Heights, wisteria in full bloom threads itself through delicate wrought-iron arches and the second-floor balcony, contrasting with the bright red of the brick and patinated green of the ironwork.

Opposite: In what looks like the entrance to a country garden, yellow roses cascade from an arbor and bloom at the same time as the wisteria and a flowering white crab apple.

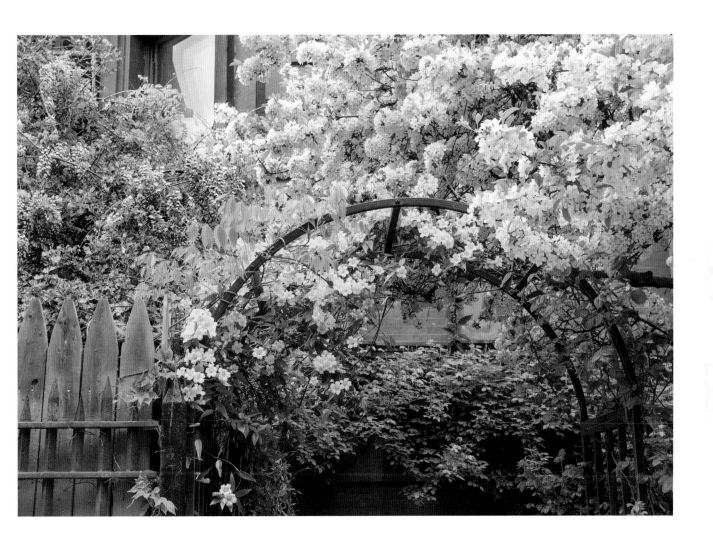

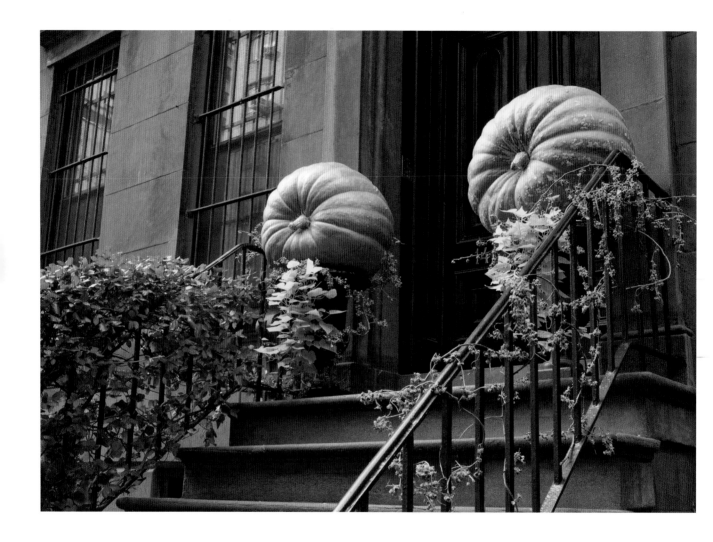

Above: Oversized pumpkins,
underplanted with sweet potato
vines and bittersweet laced
through the railing, announce
that Halloween is coming to this
Murray Hill townhouse.

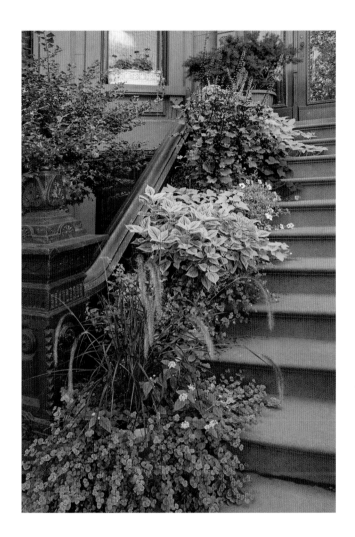

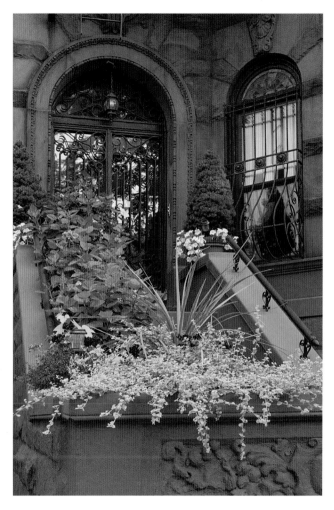

Above, left: Luxuriant foliage cascades down the steps of a Carroll Gardens, Brooklyn, town-house—flowers aren't needed to show the fruitfulness of the late summer.

Above, right: The built-in planter box enables mass planting of one type of plant to great effect, here a silver-leafed vine that com-plements the pinky-brown stone of the house in the Bedford-Stuyvesant neighborhood of Brooklyn.

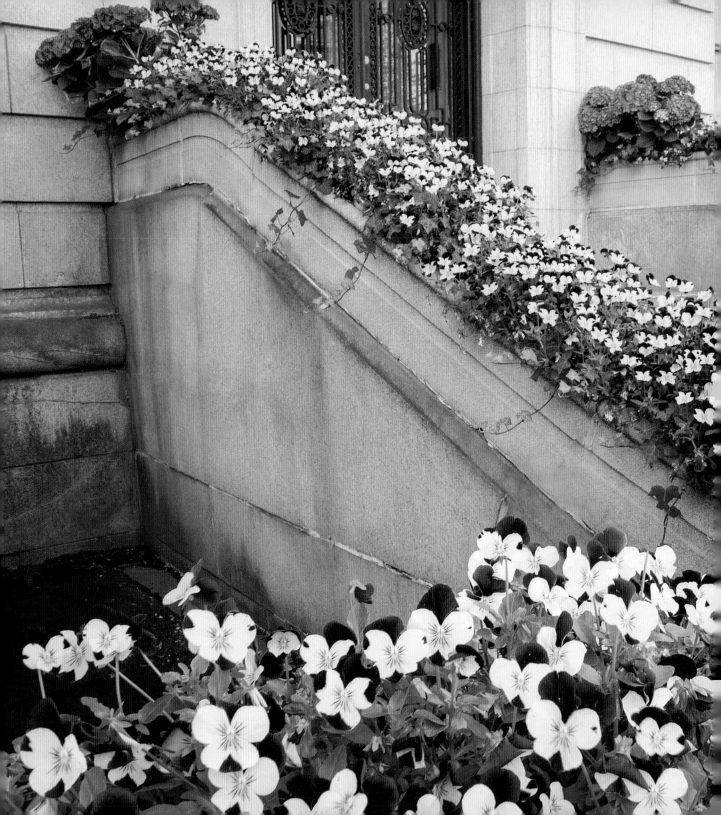

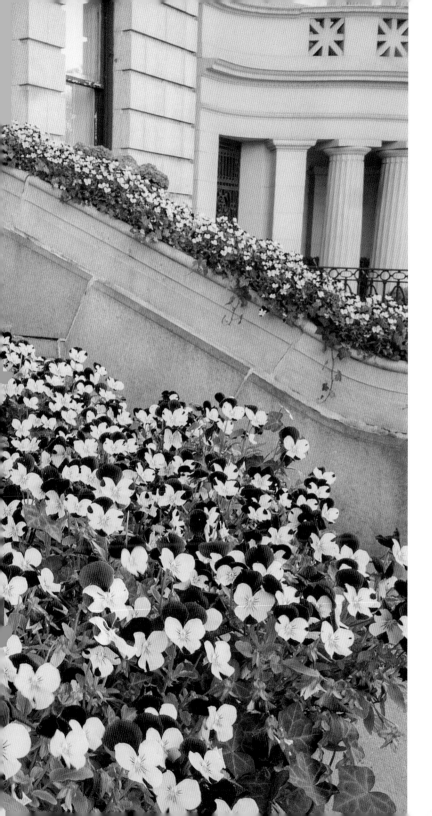

A grand townhouse on East 79th Street offers a bold and luxurious display by filling a built-in handrail planter with yellow and purple violas, spring-flowering plants that can bloom from March through late May.

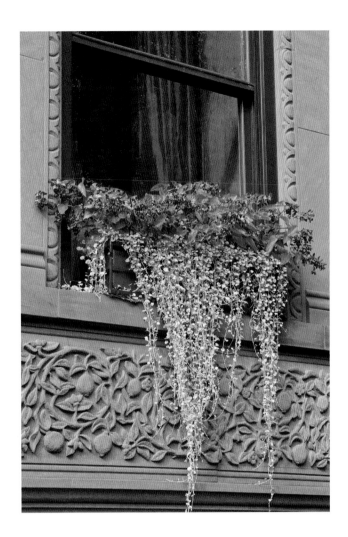

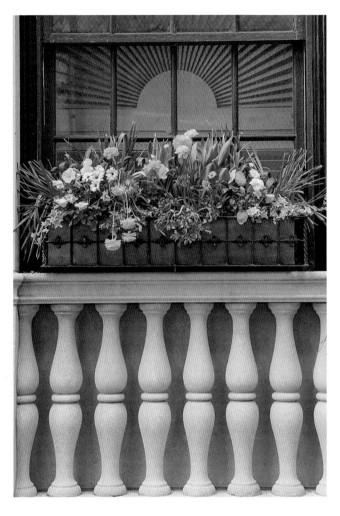

Above, left: Red begonias and a trailing dichondra complement the elaborate floral bas-relief of the brownstone building. There are identical plantings in the sixteen window boxes on this building in the West 70s.

Above, right: A spring mix of yellow ranunculus and small bulbs sits happily above a stone balustrade.

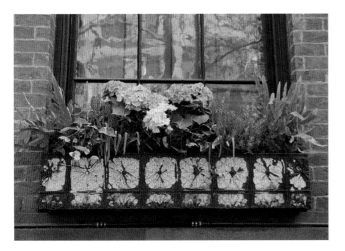

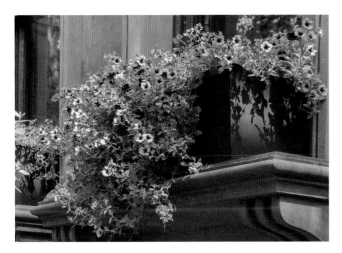

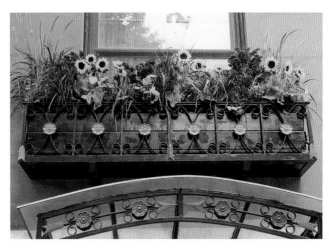

Interesting containers with uncommon plants make spectacular window gardens.

Clockwise from upper left: The window box with weathered white tiles works well with pale blue hydrangeas and blue grape hyacinth; trailing black and lime colored sweet potato vines, white bacopa, and several varieties of coleus show that flowers are not needed for color; an iron and painted wood window box holds small sunflowers and grasses, like a prairie meadow; a black container is smothered with blooms of a pale lavender petunia with a darker center.

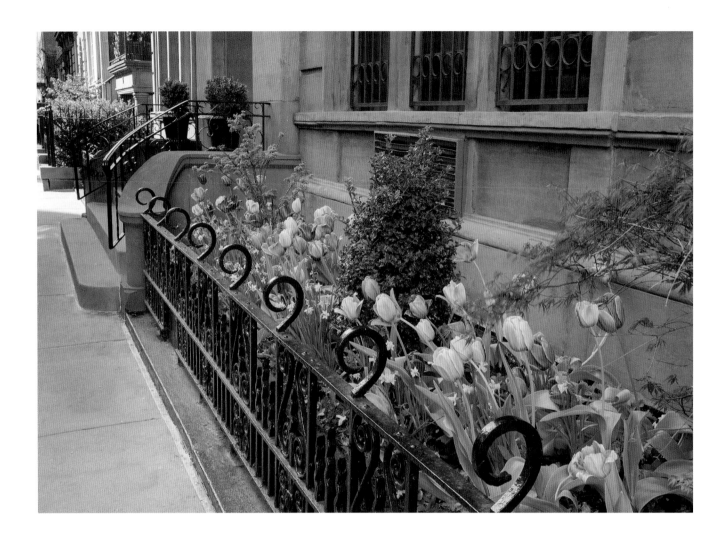

Above: The deep planters in front of a brownstone in the East 60s combine small yellow daffodils and pink and coral tulips, which share the space with a small Japanese maple, boxwood, and a rose bush that is just leafing out.

Opposite: Containers fixed to the fence support an attention-getting mix of yellow daffodils, pink and red tulips, and pink, burgundy, and purple hyacinth.

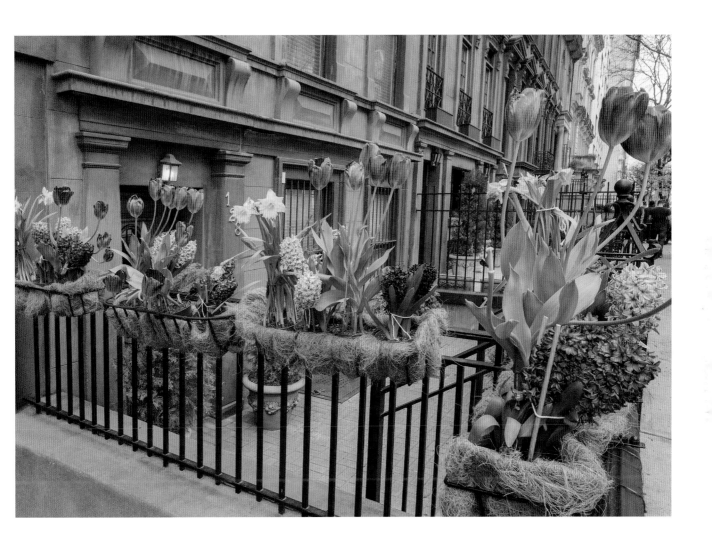

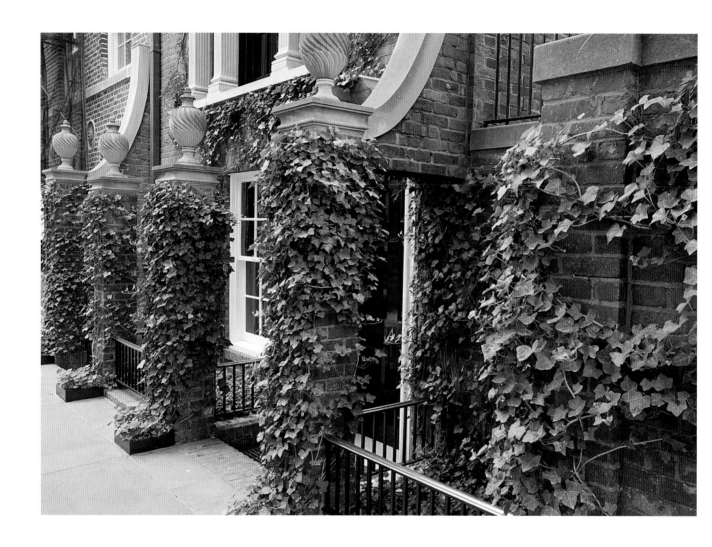

Above: Green vines, with or without flowers, soften the facades of townhouses. Off Sutton Place, ivy has been trained to cover brick piers, leaving the urns free of leaves.

Opposite: A variegated euonymous shrub grows up the side of a staircase, providing light-green and yellow color that works well with white clematis in full flower.

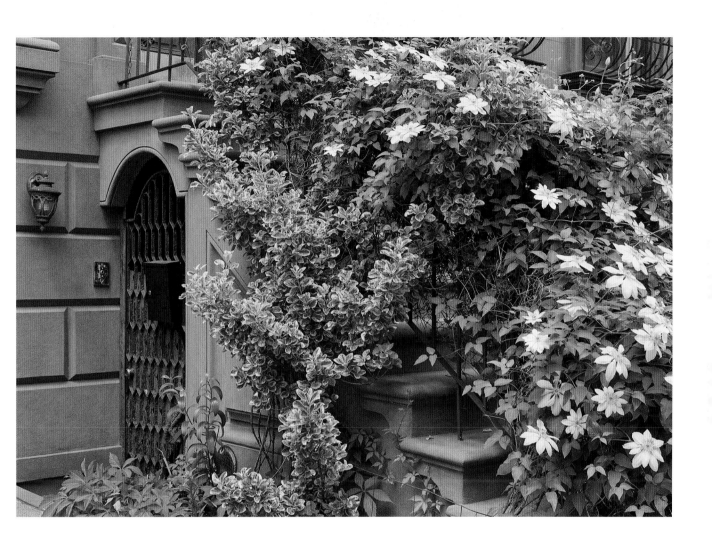

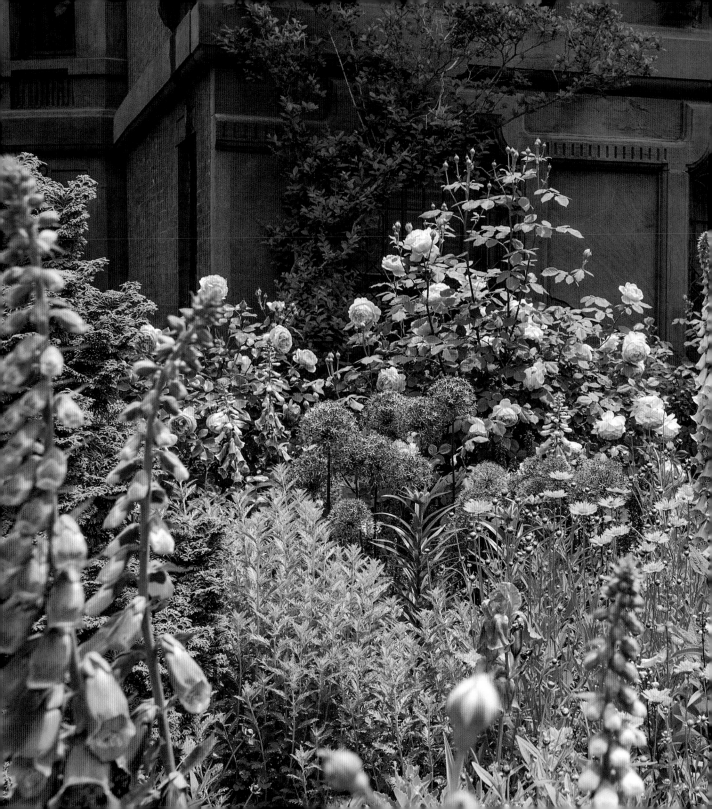

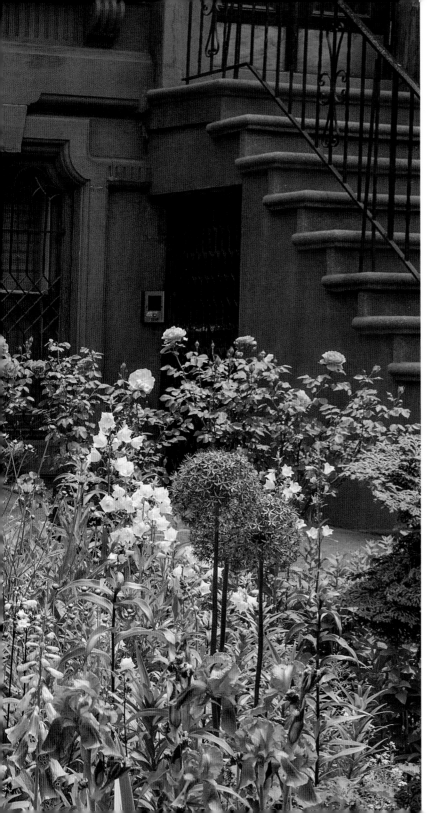

This joyous English-cottage-style garden in the front yard of a brownstone in Fort Greene, Brooklyn, is filled with roses, foxgloves, allium, iris, coreopsis, and bellflowers.

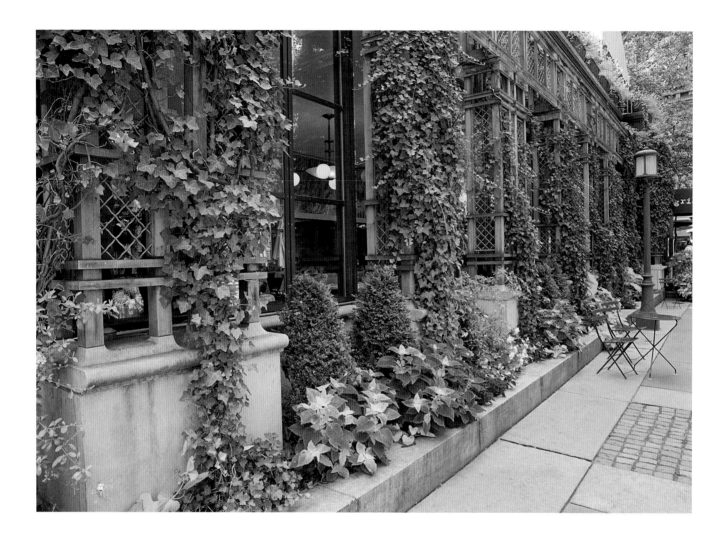

Above and opposite: The Bryant Park Grill, overlooking the park, has seasonal plantings by Maureen Hackett. In the early fall, containers are filled with coleus and boxwood. A luxuriant summer display features pale blue plumbago, sweet potato vines, petunias, and dark coleus.

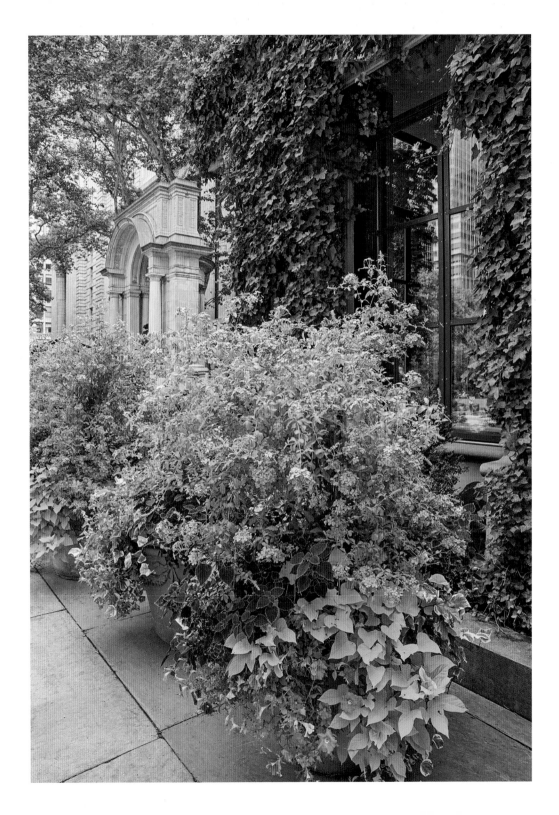

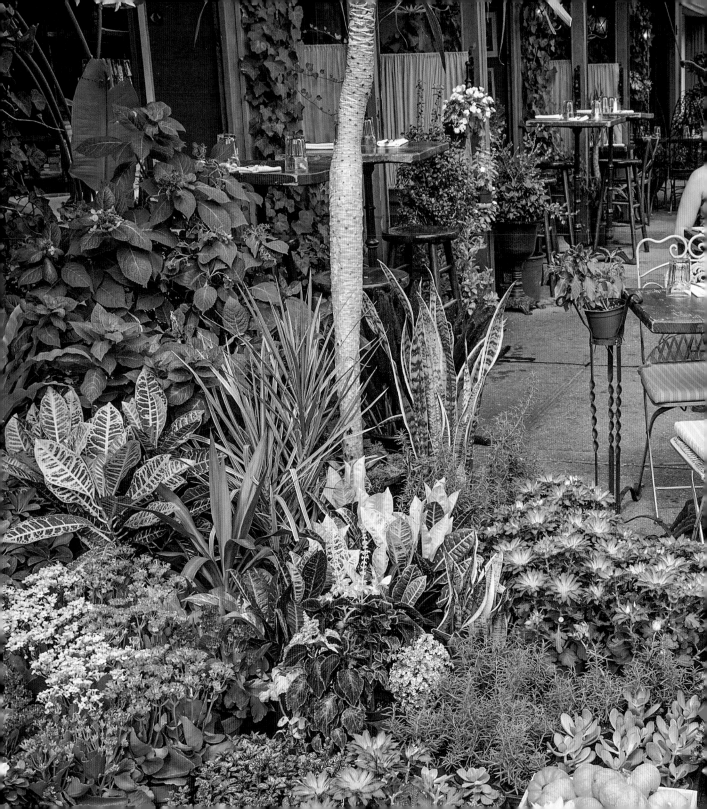

Al fresco dining at Olio e Piú in Greenwich Village is enhanced by flowers and foliage, provided by Casey's Flower Studio next door. The planting boxes create a visual boundary and delight diners and passersby with the colors of chrysanthemums, snake plants, croton, and other foliage plants.

Community Gardens:
Food, Flowers, and Friendship

Awareness of the benefits of growing food locally and the elemental drive to garden have led to the growth of more than six hundred community gardens throughout the five boroughs. Each vibrant oasis has a unique story: some were created on seemingly abandoned lots appropriated by concerned neighbors fighting urban decay; many were allocated by a city agency; and others still were started on donated land. Most have founding champions and local leadership, and reflect the cultures and food preferences of their communities, using the sweat equity of their members to improve their neighborhoods and make the city more livable. Most provide allotments that can be gardened by individual families and have shady places to sit, talk, and eat. The presence of goldfish ponds, birdbaths, and gazebos make some feel like pocket parks as much as urban farms. Rules tend to be few and simple, and there is extensive sharing of the resulting garden bounty—flowers, herbs, vegetables, and fruit.

There's been an increase and expansion of community garden organizations that help community gardens succeed. These organizations include Bronx Green-Up, Greenmarket School Tours, Green Guerillas, the city's GreenThumb program, the New York Restoration Project, and the Trust for Public Land. Collectively they deliver support to community gardens by providing technical and educational expertise, tools, mulch, and access to plants. They also work with community gardens on environmental initiatives such as capturing rainwater and on political initiatives such as securing their gardens for the future.

This community garden is next to the playground of PS 125, the Ralph Bunche School, in Morningside Heights. Playful sculptures are interspersed among the yellow tulips with the mural "Harlem Is Our Home" on the school wall beyond.

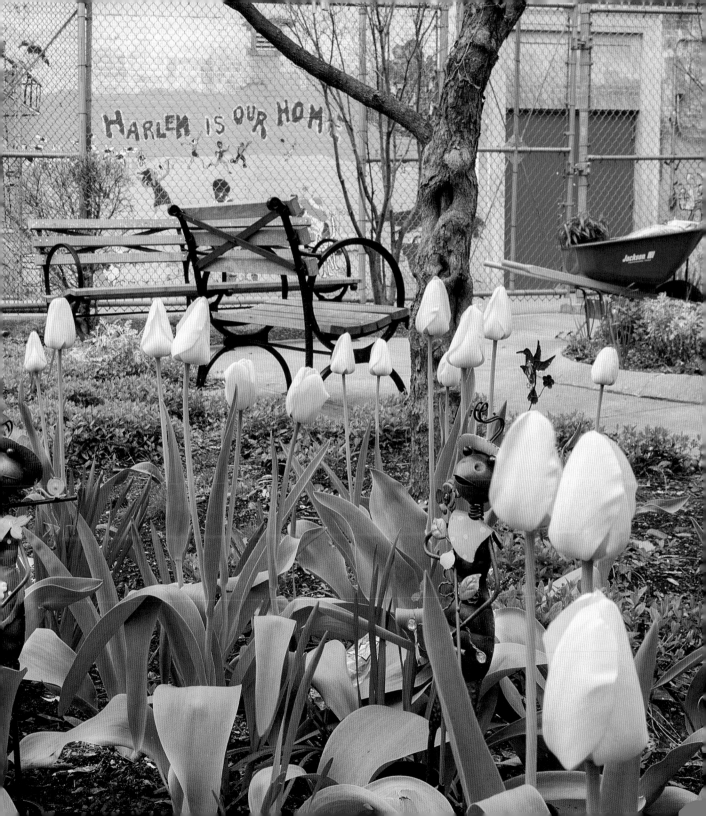

Right: Local residents fought successfully to keep open land for the creation of the Jefferson Market Garden behind the Jefferson Market Library, in Greenwich Village. Both the garden and the building are named for a food market that operated here in the nineteenth century. Managed by a community group with the help of horticulturist Susan Sipos, the garden has expansive planting beds with a mix of perennials, shrubs, trees, roses, and bulbs. Brick paths lead to a koi pond with water lilies and papyrus.

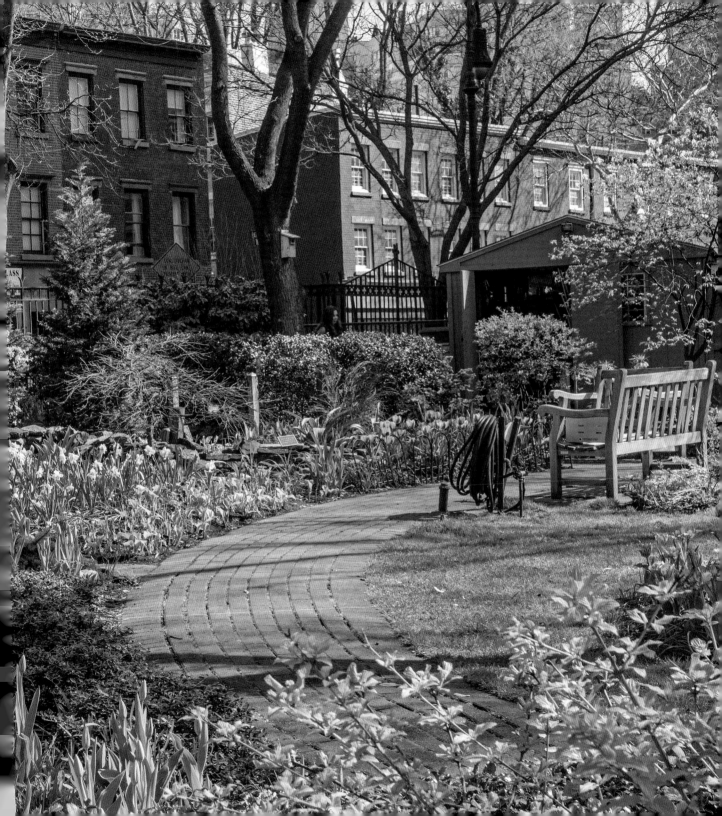

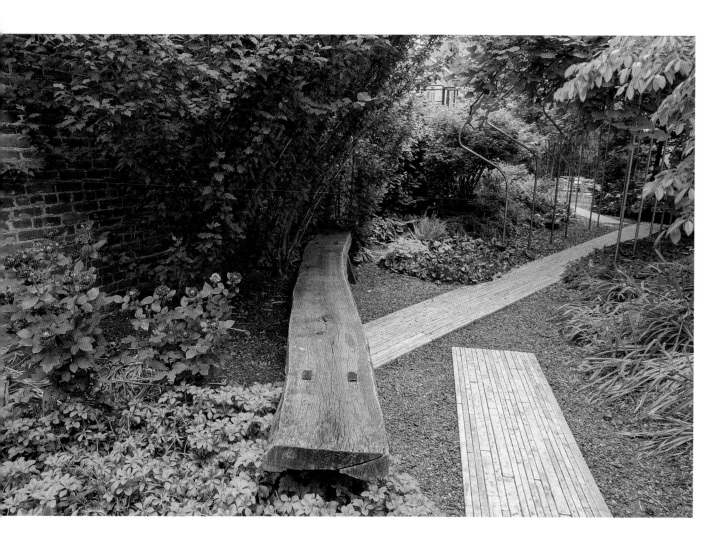

Above: The Toyota Children's Green Learning Garden in the East Village was transformed from a basic vegetable garden to an outdoor children's learning experience with four distinct habitats with support from the New York Restoration Project and funding from Toyota. Benches made of black locust wood and other structures made by local artisans enhance the space designed by Michael Van Valkenburgh Associates.

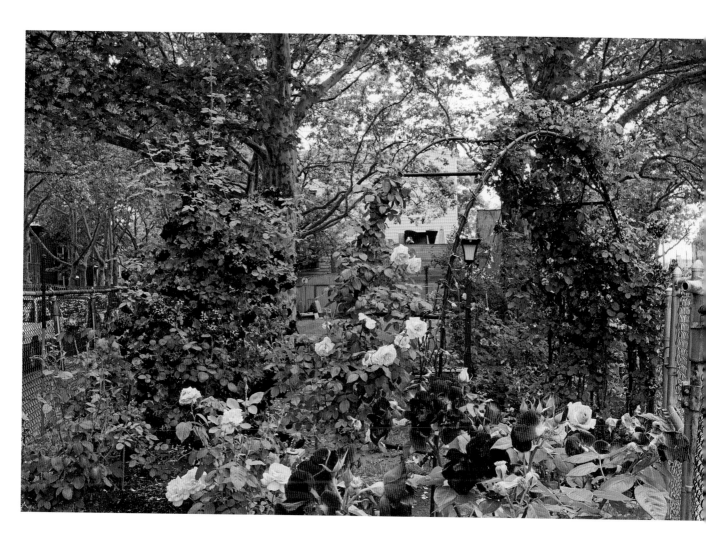

Above: The Orient Grove Community Garden in Williamsburg, Brooklyn, a small triangular garden, features roses that flourish largely due to the hard work and commitment of volunteer Dominick Ferro. Community gardens need a sponsor to thrive, and Ferro has been the garden's champion for decades.

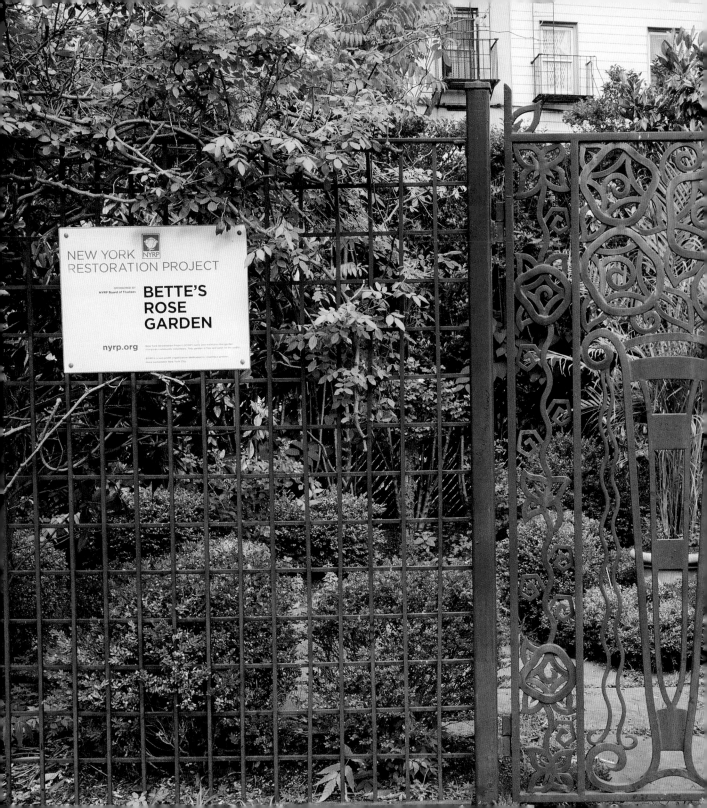

Bette Midler is the founder and driving force behind the New York Restoration Project. Initially set up to clean up neglected parks, NYRP is now a conservancy with a broad mission to protect and preserve community gardens and other green spaces.

In honor of Midler's sixtieth birthday, the trustees commissioned landscape architects Sawyer Berson to transform this space in the Bronx into a rose garden with a decorative fence. Near the Arturo Toscanini school, the garden also serves as an outdoor classroom where students learn how to grow food and nurture a garden.

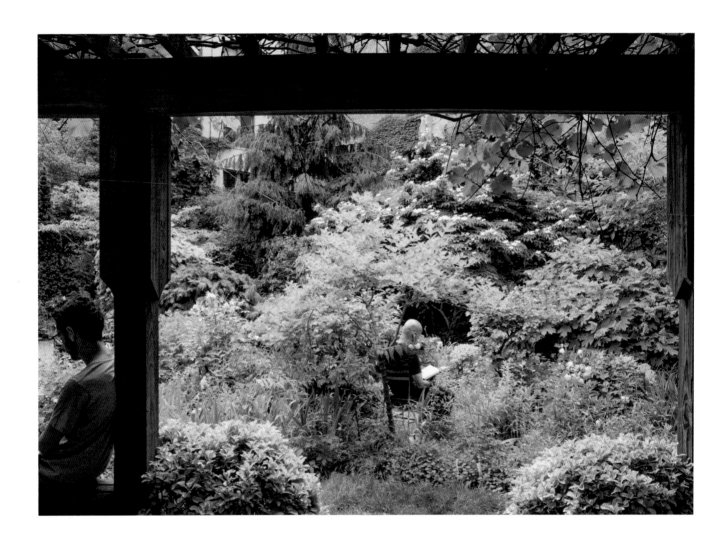

Above: 6CB Botanical Garden on the Lower East Side is a community oasis densely planted with ornamental plants. This a GreenThumb garden, planted and maintained by volunteers.

Opposite: An arbor festooned with yellow roses leads to the gardens of the Church of St. Luke in the Fields in Greenwich Village.

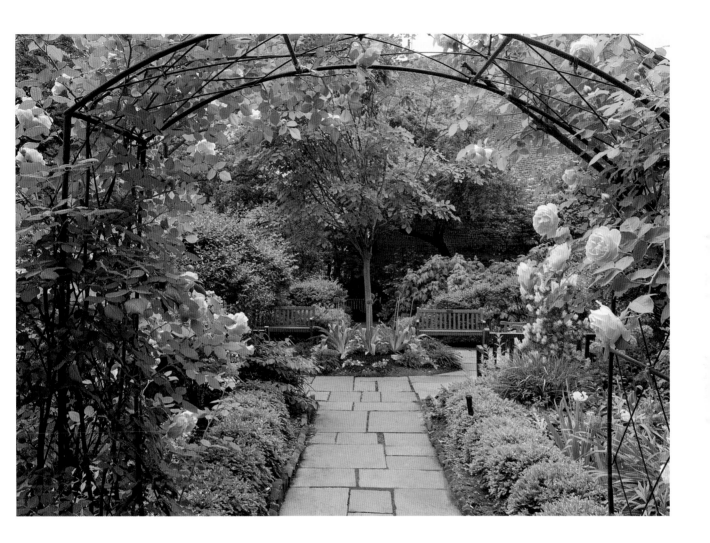

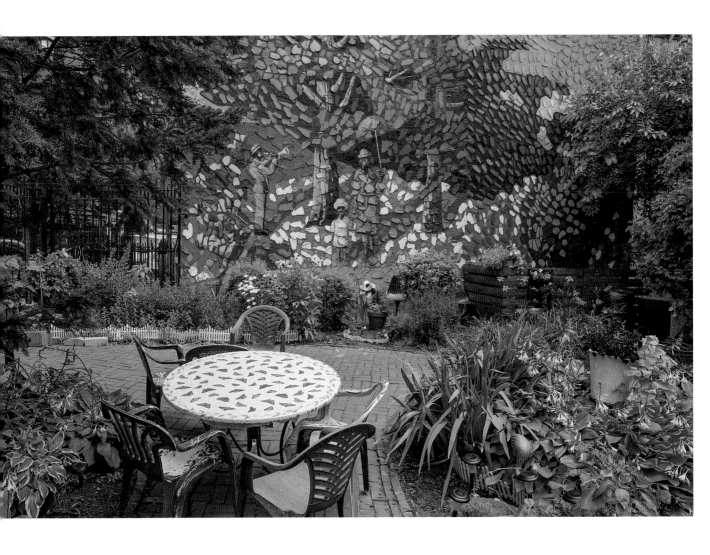

Above: The Hope Steven Garden,
at Amsterdam Avenue at 142nd
Street, features a mural entitled
*Homage de Seurat: L.a Grande
Jatte in Harlem.*

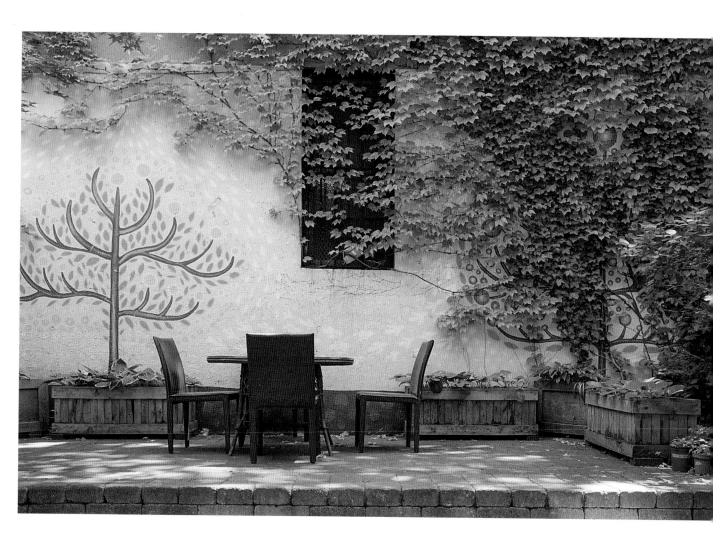

Above: The All People's Garden on the Lower East Side was carved out of two city-owned vacant lots, cleaned up and planted by community volunteers, and eventually established in perpetuity through an agreement between the city and the Trust for Public Land. The whimsical mural brings additional light and color into a shady space, and serves as a backdrop for many community events.

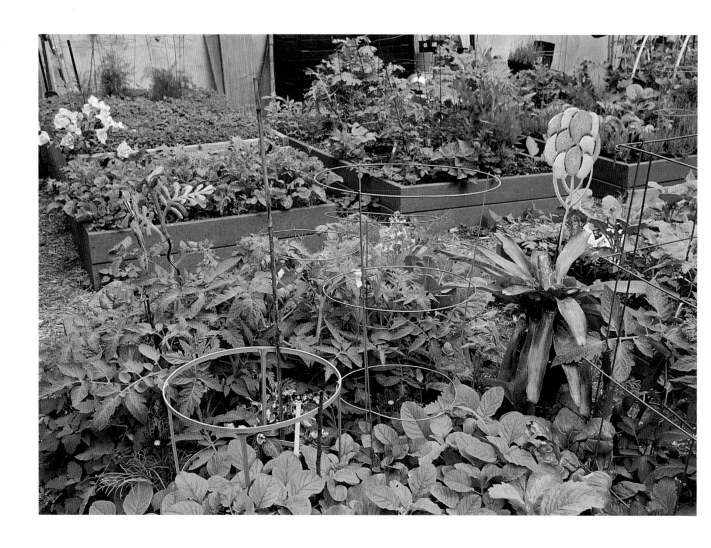

Above and opposite: Community gardens often combine vegetables, flowers, and herbs with quirky garden sculptures and murals. A thriving peony plant and whimsical sculpture enhance the Campos Community Garden, a 5,000-square-foot GreenThumb garden in the East Village on East 12th Street between Avenues B and C.

The New Roots Community Garden, on the Grand Concourse in the Bronx, was established in 2012 by the International Rescue Committee in collaboration with Bronx Green-Up, a community garden outreach program of the New York Botanical Garden. The block-wide New Roots Garden has a hoop house that shelters flats of seeds and young plants in the spring, thirty-four community garden beds, planting beds for perennials and herbs, a composting area, two behives, and eleven beds for teaching purposes and growing vegetables to sell in local markets.

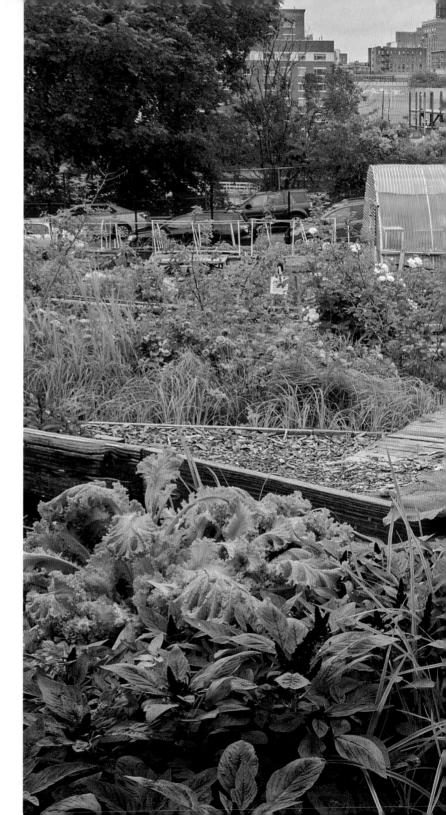

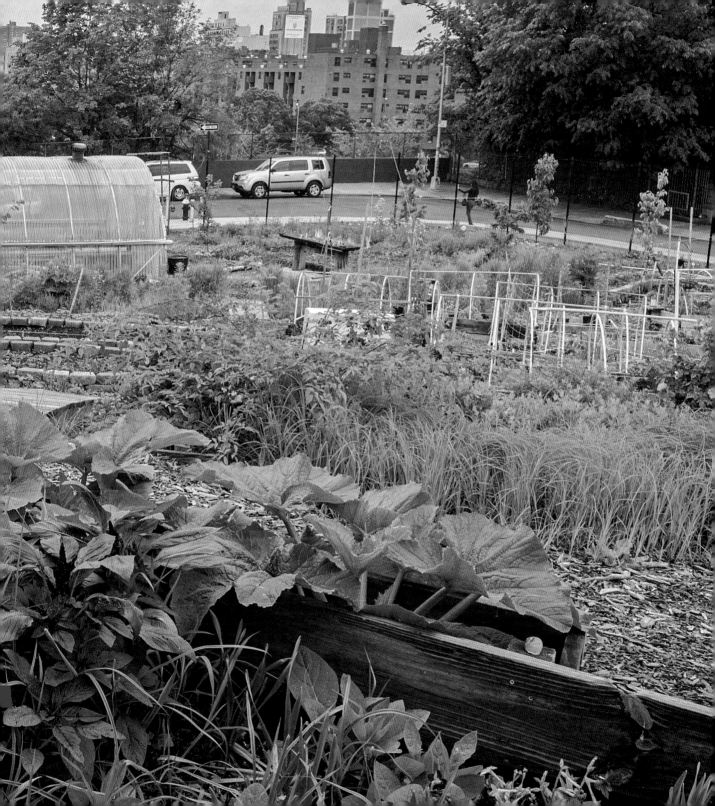

Above: In the Jackie Robinson Garden in East Harlem, community members grow vegetables and flowers in colorful raised beds. These have enormous advantages for gardeners in terms of ease of reaching into the beds to weed and cultivate the soil.

Opposite: Potted herbs and vegetables, including corn, supplement the fully planted garden beds in the outdoor classroom of PS 212 Midtown West School in Hell's Kitchen.

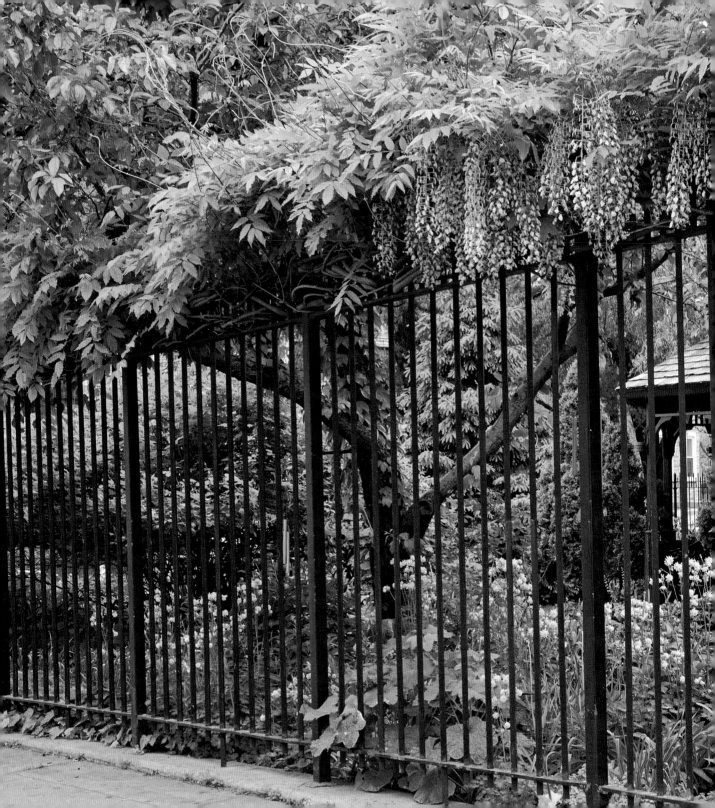

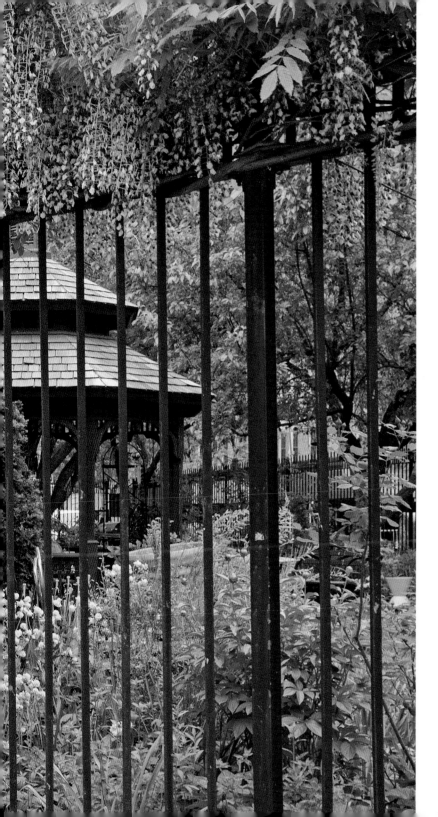

Convent Garden, in the Sugar Hill section of Harlem, is enclosed by a fence draped with wisteria, which beautifully foreshadows the lushness of the plantings within. The gazebo, donated by the Marriott Corporation, provides a shady place to sit after working in the garden. The Convent Garden Community Association works with the NYC Parks Department to maintain the garden.

Above: Dark-orange lilies in a plot of the Juan Alonso Garden in Hell's Kitchen bloom for weeks in July and August. The garden is now maintained by CultivateHKNY, dedicated to nurturing open space and gardens in that neighborhood.

Above: Adorning the fence near DeWitt Clinton Park is a vigorously blooming clematis vine, part of Maria's Perennial Garden, which features flowers of the 1800s and plants that attract birds, bees, and butterflies. Roses thrive nearby, creating a fragrant and beautiful boundary between the sidewalk and the smaller plantings within the garden.

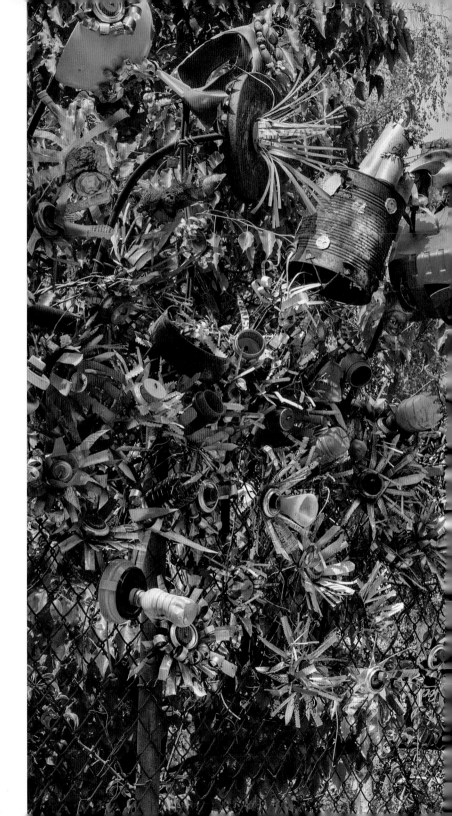

La Plaza Cultural–Armando Perez
on the Lower East Side functions
as a community garden, outdoor
theater, and event space. This
extraordinary fence, designed
by Rolando Politi, features tin
decorations donated and placed
by community residents, giving
this venue a playful personality.

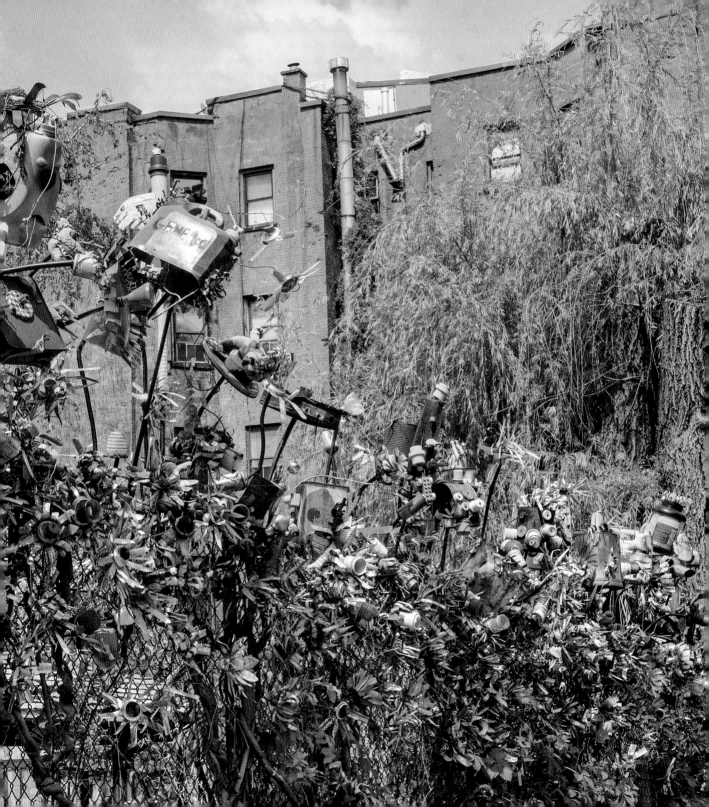

Along the Parks:
Borrowed Landscapes

New York has a vast "Emerald Empire" with more than 1,700 parks, playgrounds, and recreational facilities. There was a time in the 1960s and 1970s when the crown jewel—Central Park—was deteriorating into a dangerous, unkempt eyesore. The park has experienced several periods of renewal and decline during its 160-year history, but the most recent decline led to the formation of the Central Park Conservancy in 1980. Private funds are used to augment what the NYC Parks Department can support, and the park has been transformed into a vibrant and beautiful destination. Public/private partnerships have led to revitalization of not only this Frederick Law Olmsted masterpiece but also other parks throughout the city. One of the latest high-profile examples is the High Line, a public park built on an elevated freight line owned by the city and operated by the Friends of the High Line. Other active groups include the Carl Schurz Park Conservancy, the oldest community-based volunteer park association in New York City, as well as the more recently established conservancies for Brooklyn Bridge Park, Madison Square Park, and Four Freedoms Park.

A current initiative by the NYC Parks Department is Parks without Borders, focused on improving park entrances, edges, and spaces adjacent to parks. What we can see around the edges of a park is inspiring to the pedestrian and helps to extend the beauties of the park out into the community.

The Cherry Tree Mall is the entrance to Carl Schurz Park, designed by Frederick Law Olmsted. The 15.2-acre park extends from 90th Street, just north of Gracie Mansion, to Gracie Square at 84th Street and includes a beautifully landscaped promenade along the East River.

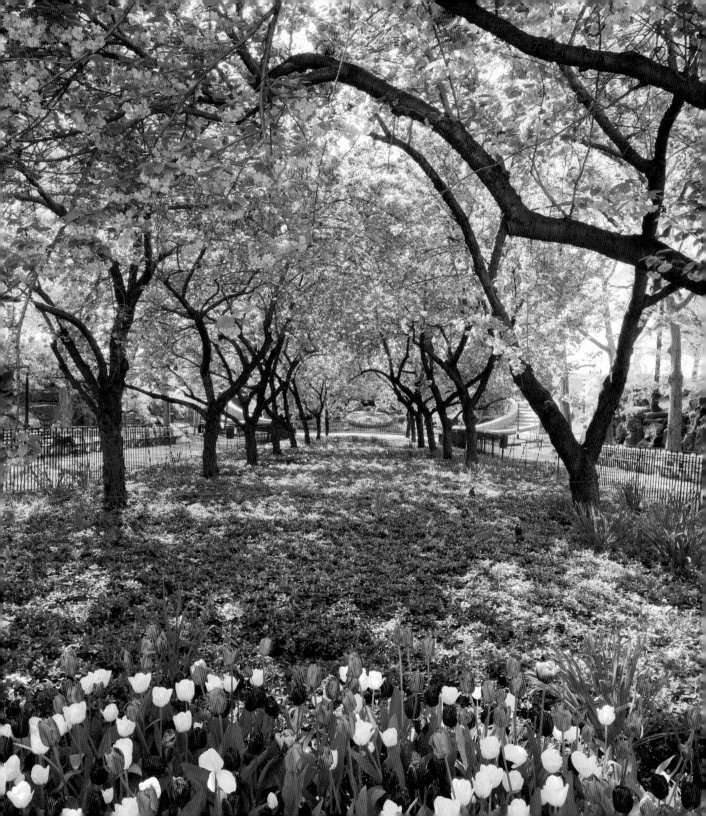

Above and opposite: The wide sidewalks around the perimeter of Central Park allow beautiful views into the park, with many plantings positioned so that pedestrians can see the exuberant spring tulip display and the colorful flowering trees. The stone perimeter walls are an original element of the Greensward Plan, the design by Frederick Law Olmsted and Calvert Vaux; five miles of stone walls surround the 847-acre park.

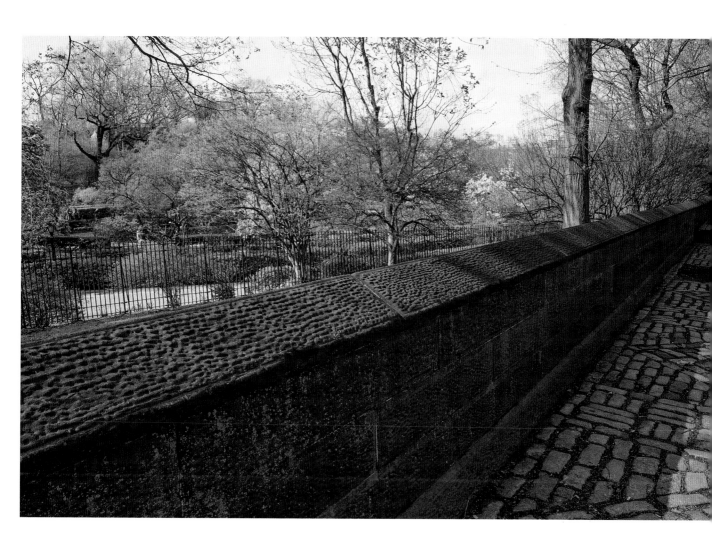

Overleaf: The Harlem Meer is one of five large bodies of water in Central Park. Located at the northeast corner of the park, this lake is surrounded by many varieties of trees, including oak, bald cypress, beech, and ginko as well as the weeping willow, which is striking in the early spring.

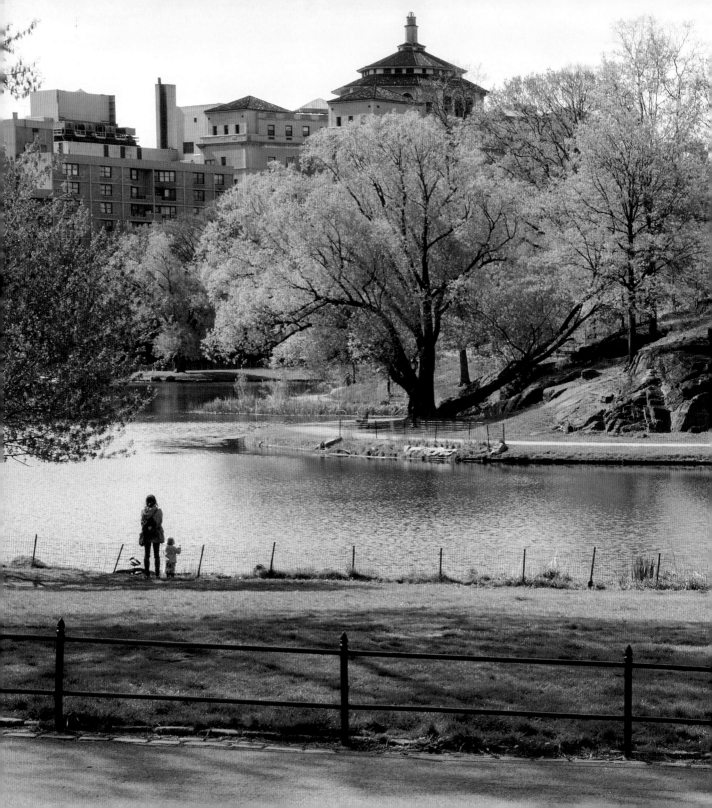

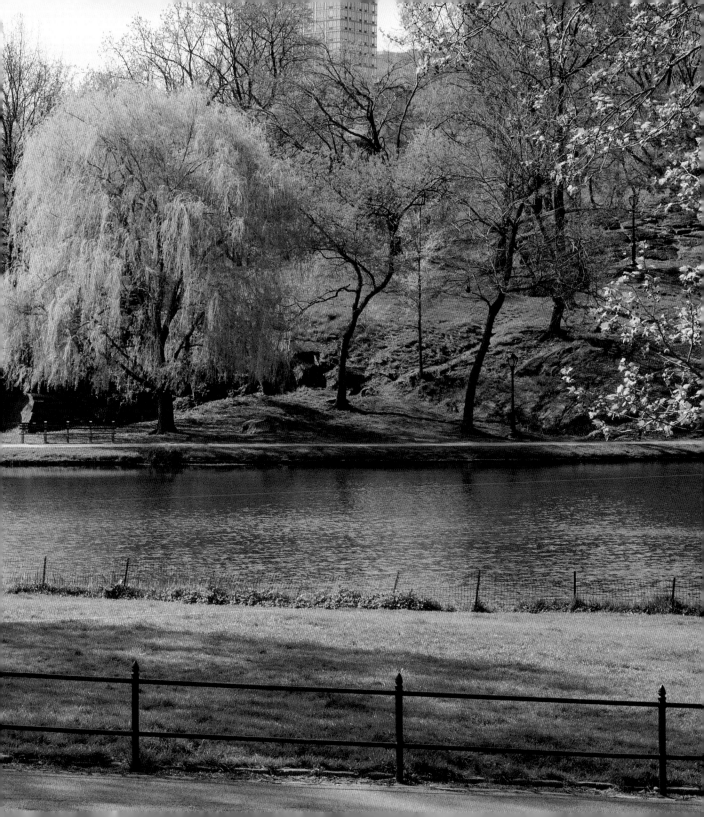

Above: Bright-orange day lilies stretch for light at an entrance to Riverside Park, which was designed in the English garden style by Frederick Law Olmsted.

Opposite: The Heather Garden in Fort Tryon Park lies 200 feet above the Hudson River. Reinvigorated by Lynden B. Miller and Rhonda M. Brands, the border now blooms with shrubs, perennials, and bulbs in addition to heaths and heathers.

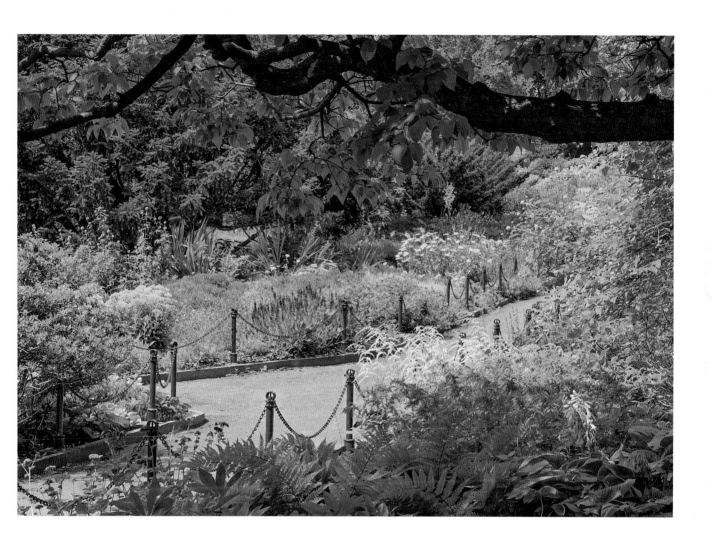

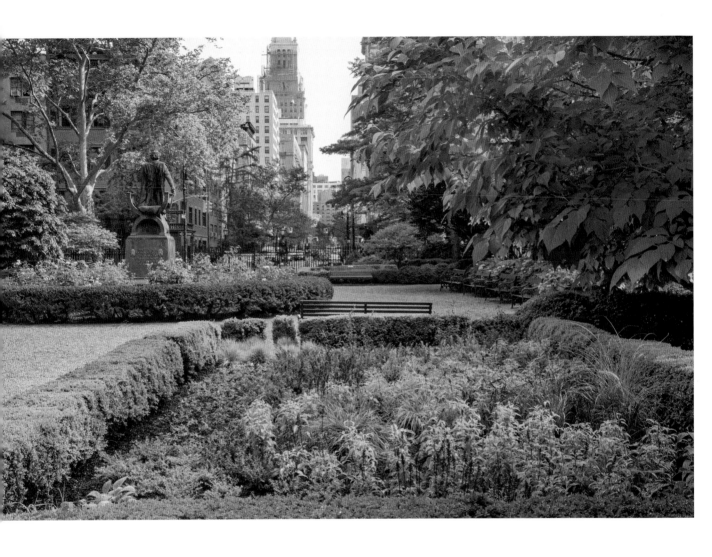

Above and opposite: Gramercy Park is a two-acre private park open only to those who live in the buildings that surround it, but perimeter plantings along the wrought-iron fence offer pedestrians views of the extensive shrubbery, cooling fountains, flowering trees and planted flowerbeds. The beauty of the park carries over to the planted tree beds and front gardens of the neighboring buildings.

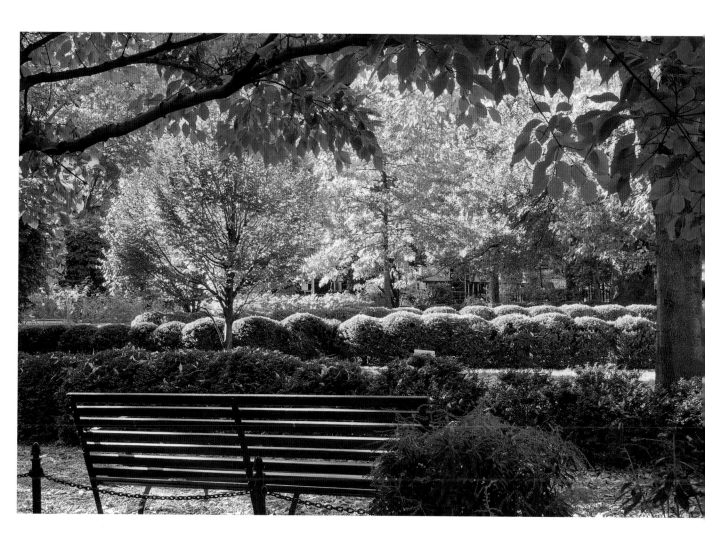

Overleaf: The view from Vanderbilt Gate, at Fifth Avenue and 103rd Street, embraces the central portion of Conservatory Garden. This formal Italian-style garden is at its best in the spring when wisteria blooms on the pergola framed by a double allée of crab apple trees. The garden is flanked by French and English-style gardens, all designed by Gilmore D. Clarke in the 1930s and restored by the Central Park Conservatory in the 1980s.

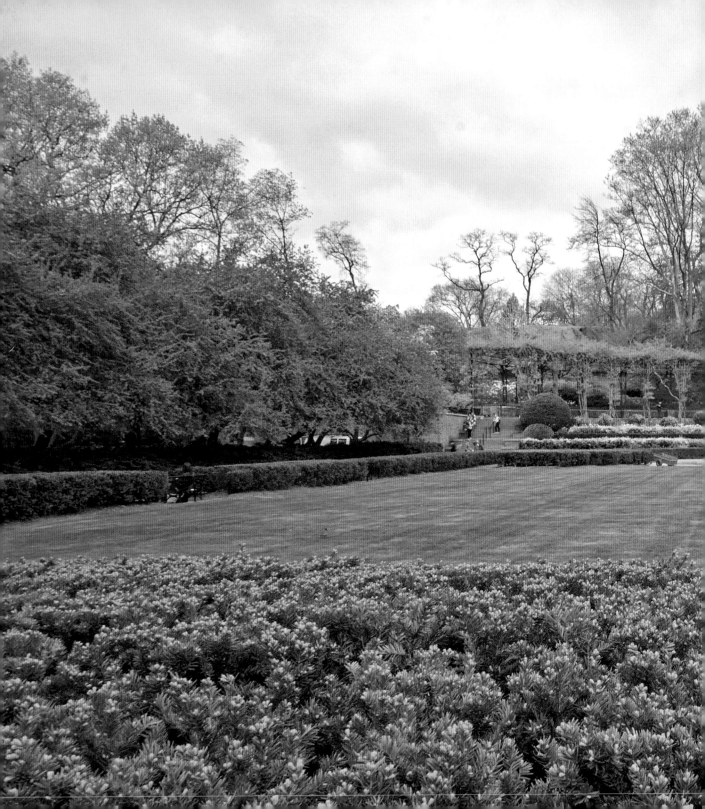

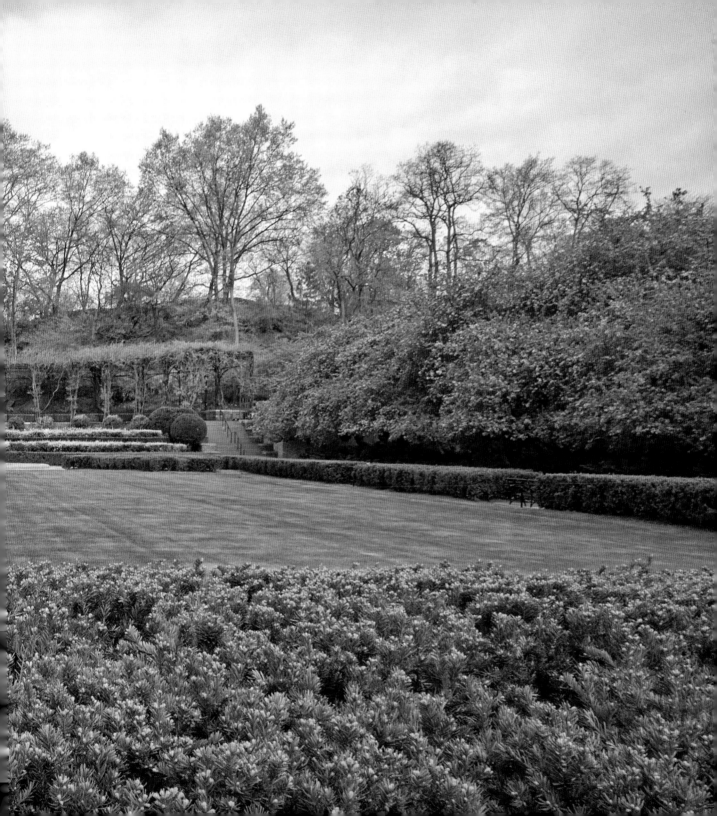

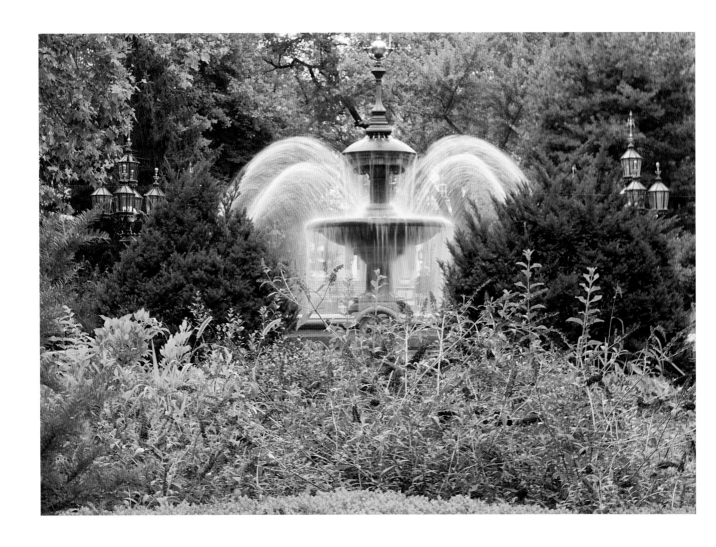

Above and opposite: City Hall Park is a green oasis in an area of government buildings and traffic. Just south of City Hall, the park has large trees, flower beds, ample seating, and this lovely fountain, designed by Jacob Wrey Mould, the co-designer of Central Park's Bethesda Fountain. A summer perennial planting with a loose, wild look, provided by dark purple butterfly bushes, follows the profusion of spring tulips.

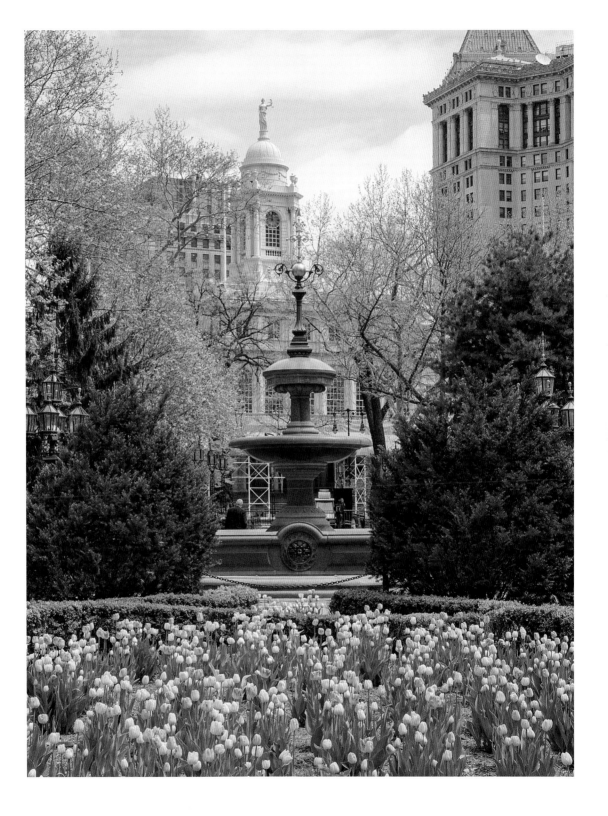

Above and opposite: Franklin D. Roosevelt Four Freedoms Park on Roosevelt Island is the last design of the modernist architect Louis I. Kahn. Four copper beech trees mark the entrance, and a double allee of linden trees leads to the granite monument inscribed with excerpts from the President's State of the Union Address in 1941.

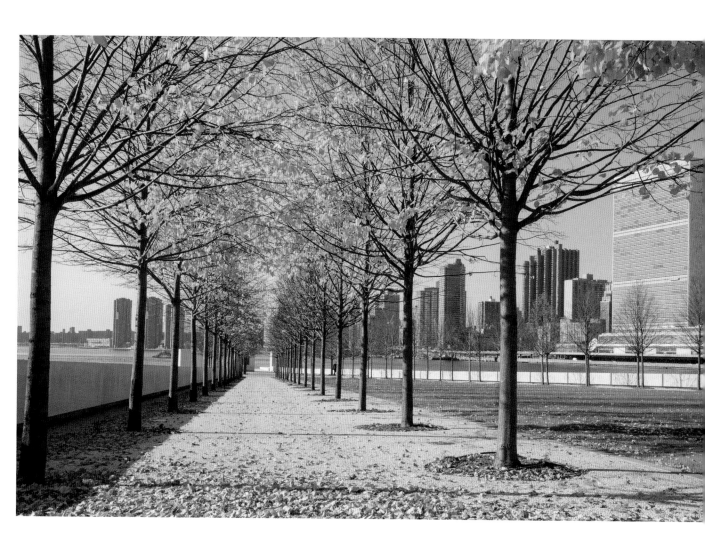

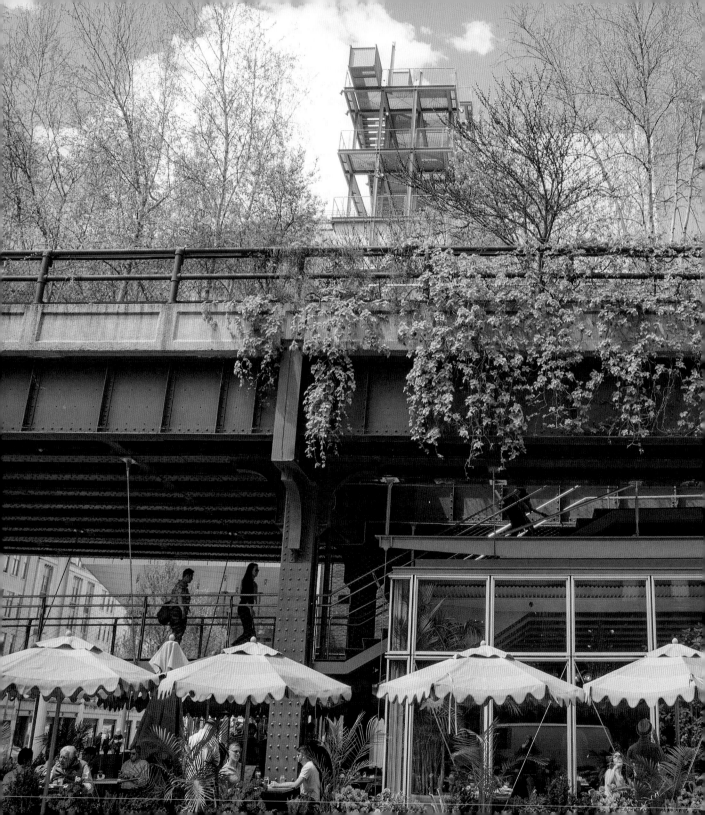

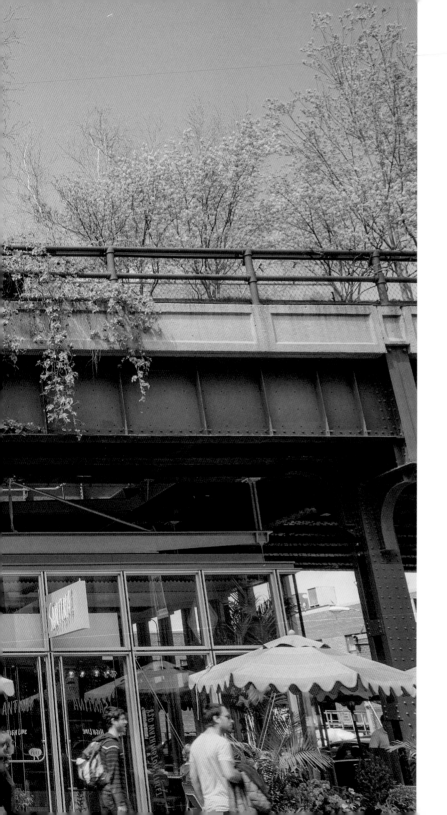

The High Line, built on an abandoned railway line, winds through the Chelsea and Hudson Yards neighborhoods from Gansevoort Street to 34th Street, and provides a garden view for people at the street level as well as those on the walkway. This is the south entrance, where flowering redbud trees and trailing ivy draw the eye upward above the brightly colored umbrellas.

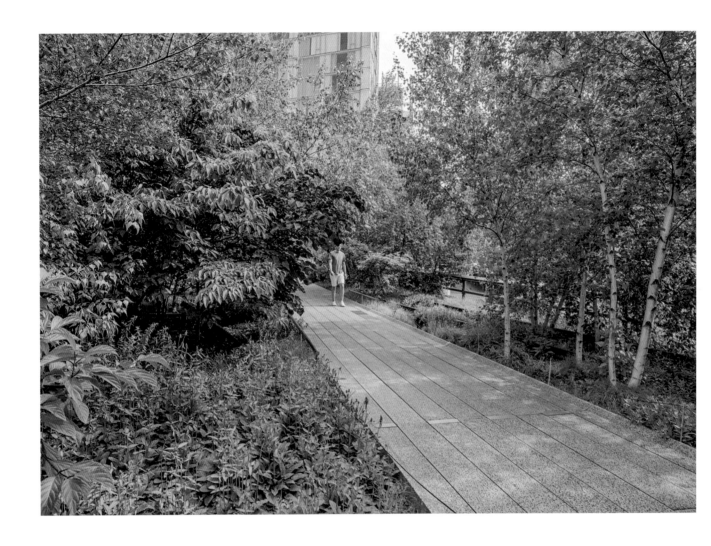

Above and opposite: The High Line's planting design was inspired by the self-seeded landscape that emerged during the twenty-five years that the railroad beds were abandoned. Dutch garden designer Piet Oudolf selected the plants using the mantra of "keep it wild," finding plants with hardiness, sustainability, texture, and color, including many native species.

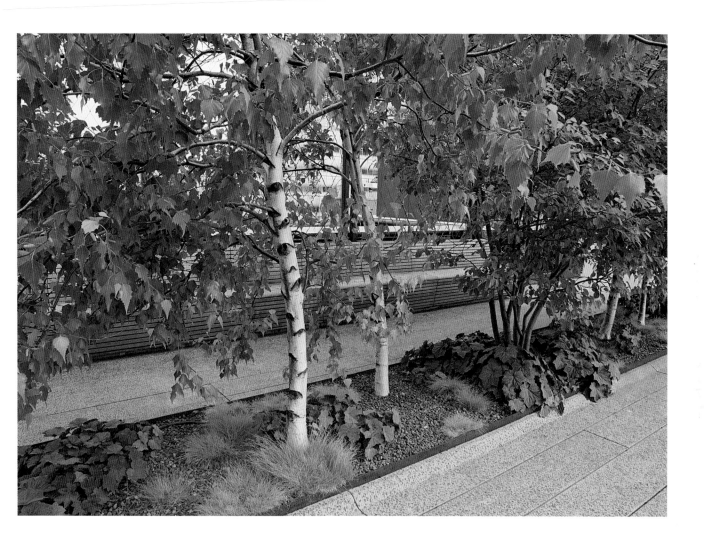

Overleaf: The use of grasses as a key part of the plant palette creates four-season effects, as even their dried foliage is attractive. The gardeners keep it through the winter and cut it down in the early spring.

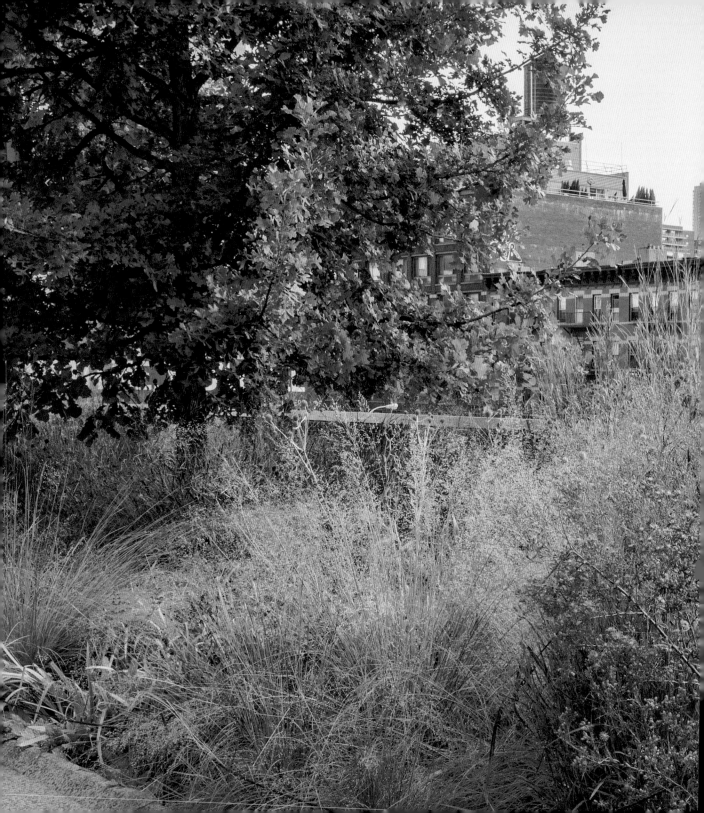

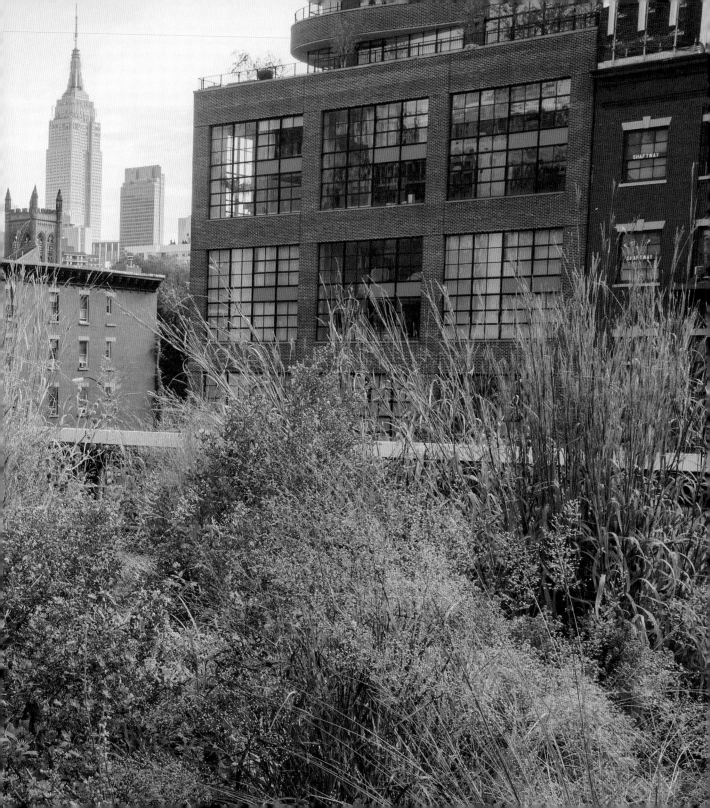

River to River:
Gardens at the Water's Edge

New York City is surrounded by water, and Manhattan is literally an island; after decades of neglect and underinvestment, there has been extensive development of the city's Blue Network, encompassing 520 miles of shoreline in all five boroughs with related investments in new parks on the waterfront. Many acres of the waterfront that have never been accessible to the public have been opened up, notably around the Brooklyn Bridge, along the Hudson River, and the Battery.

Brooklyn Bridge Park features 85 acres of lawns, gardens, meadows, wetlands, salt marshes, and trees, encompassing 1.3 miles along the East River on the Brooklyn side. Extensive gardens complement recreational facilities, including a historic carousel. Landscape architects Michael Van Valkenburgh Associates developed the master plan for the park, which is now operated by the Brooklyn Bridge Park Conservancy.

The Manhattan Waterfront Greenway extends from 59th Street south to Battery Park and provides a landscaped 550-acre park stretching 4.5 miles, providing views across the Hudson River to New Jersey. Many old shipping piers are also being transformed into parkland along the greenway.

Battery Park, overlooking New York harbor, is managed by a not-for-profit conservancy that oversees 25 acres of gardens with sweeping perennial borders featuring native plants and a grove with 140 plane trees—the Battery Bosque. In 2002 landscape designer Piet Oudolf was commissioned to develop a horticultural master plan, and the result is a luxuriant landscape that looks lovely in all seasons.

This is one of the five vest-pocket parks, known as Sutton Parks, along the East River between 53rd and 59th Streets in the vicinity of Sutton Place. Benches, roses, and planted pots make a welcoming place with views of the river and the 59th Street Bridge.

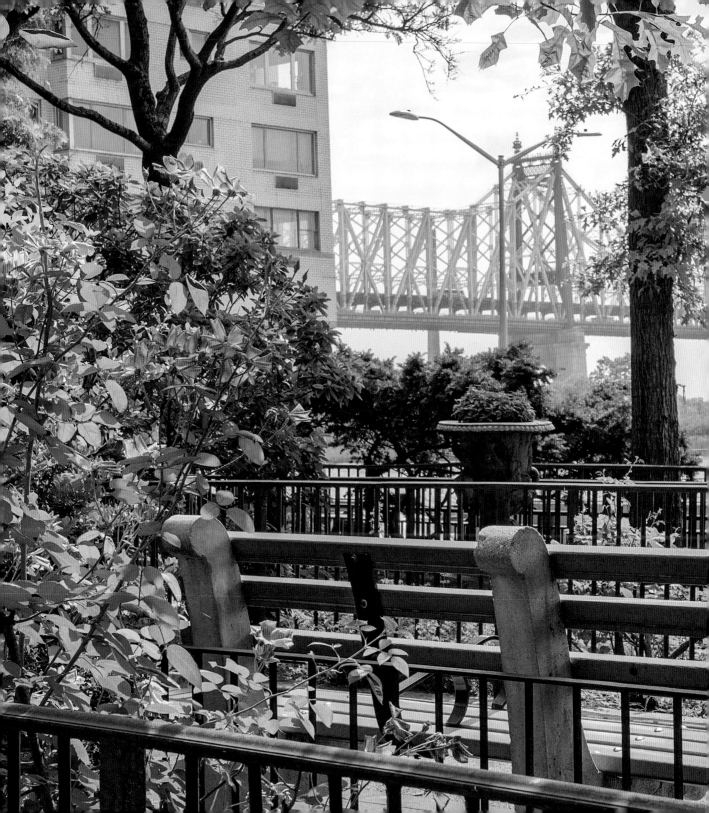

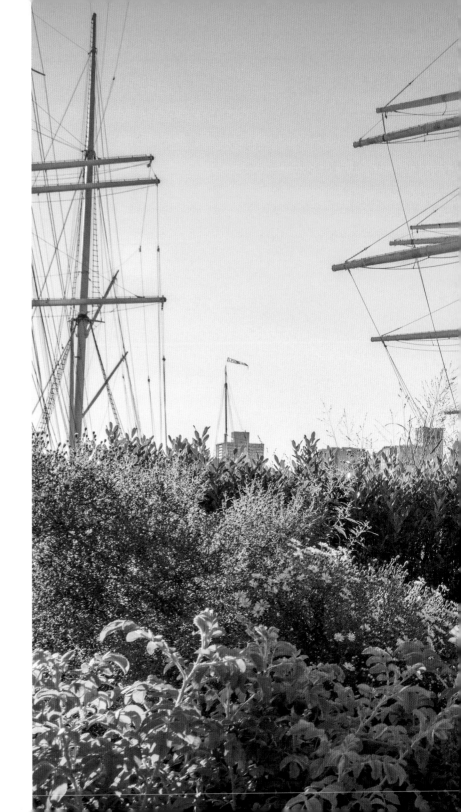

Schooners at South Street Seaport seem to be docked in a garden. Robust grasses and perennials move in the breeze and junipers help to block the wind and provide year-round color along the East River.

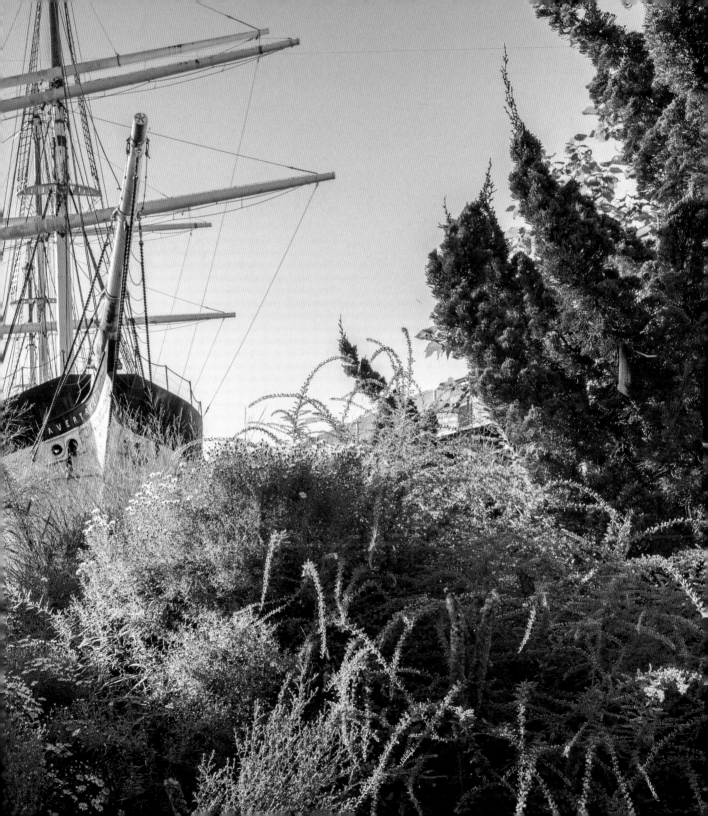

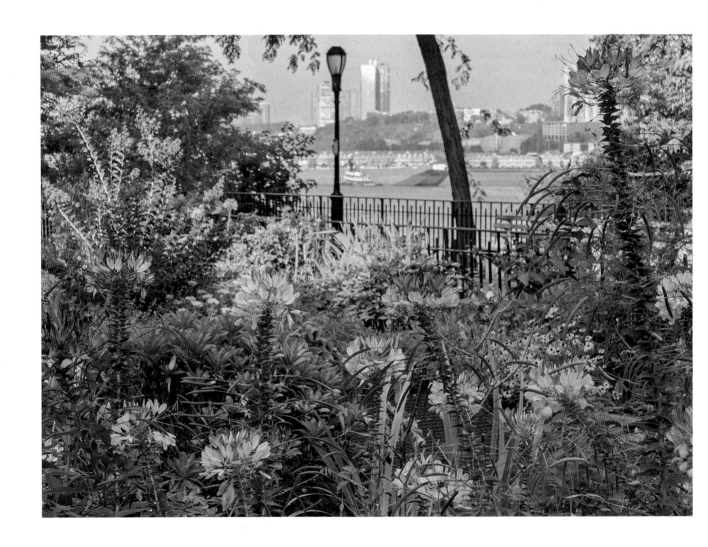

Above: Farther up the Hudson River is a very different riverside planting in the 91st Street Community Garden, managed by The Garden People, a not-for-profit organization. Volunteers cultivate individual allotments with flowers only—no vegetables—using organic methods. The bright annuals and perennials here include pink spider flowers, false spirea, and petunias.

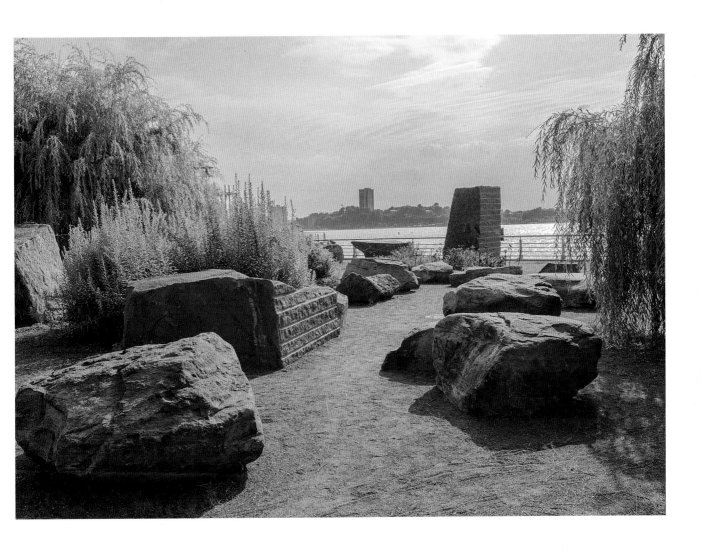

Above: Stonefield by Meg Webster is installed on Pier 63 in Hudson River Park. The huge stones, from quarries in New York State and Pennsylvania, were selected by the artist for their individual characters.

Overleaf: Hunter's Point South Park in Long Island City, Queens, designed by Weiss/Manfredi, offers a waterside promenade, playing fields, and ten acres of green space reclaimed from a post-industrial wasteland.

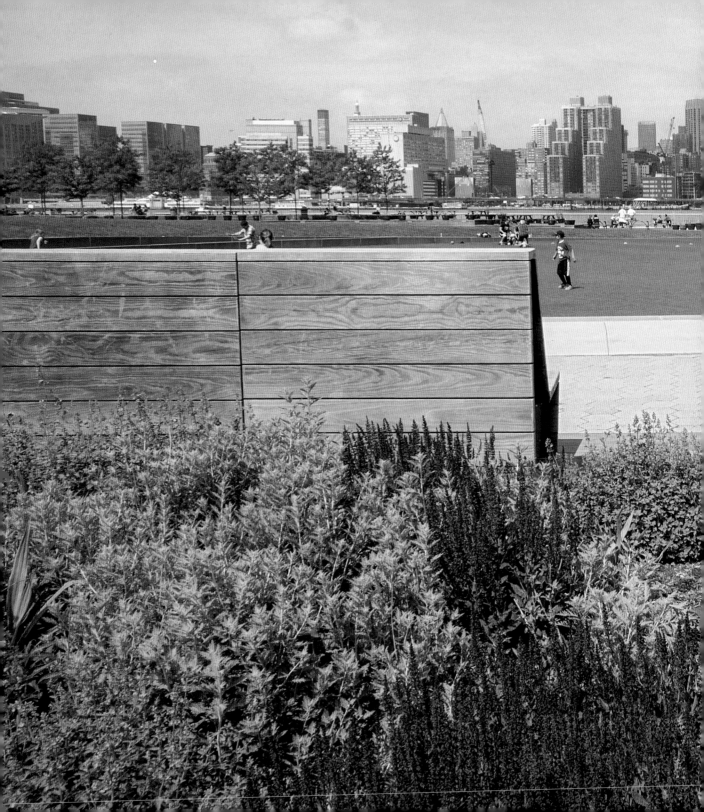

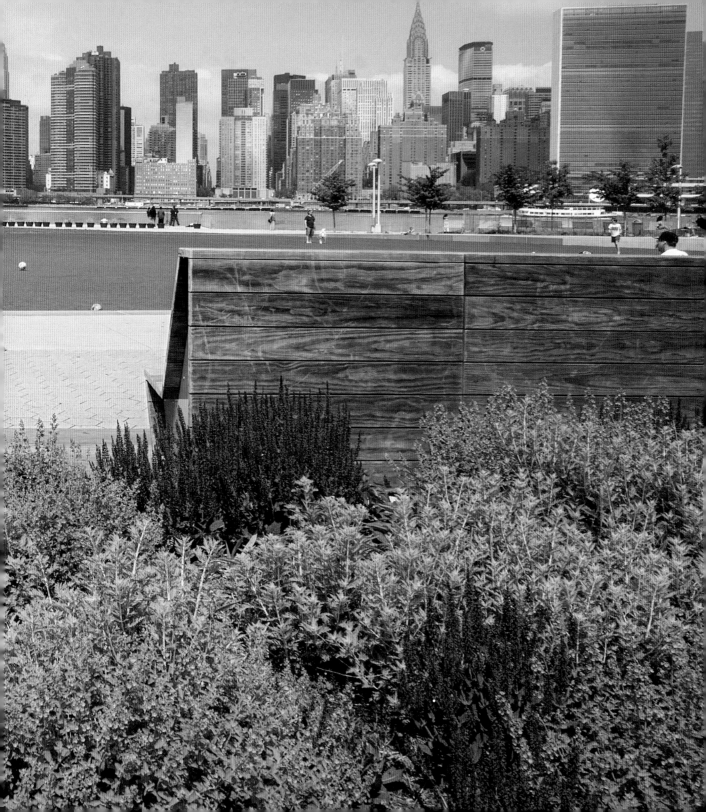

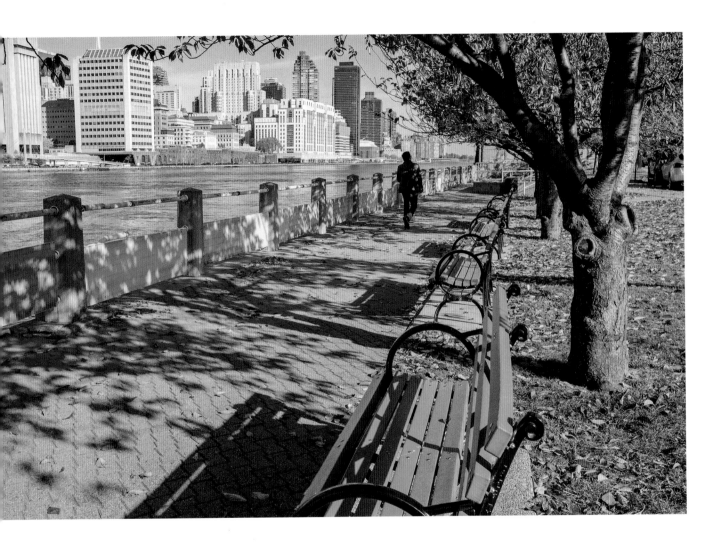

Above and opposite: The Roosevelt Island promenade runs along the East River from the lighthouse at the northern end of the island to Four Freedoms Park at the southern tip. This tranquil walkway is lined with six hundred ornamental cherry trees that have spectacular blossoms in the spring and colorful leaves in the autumn. Benches encourage sitting and watching boats navigate the river.

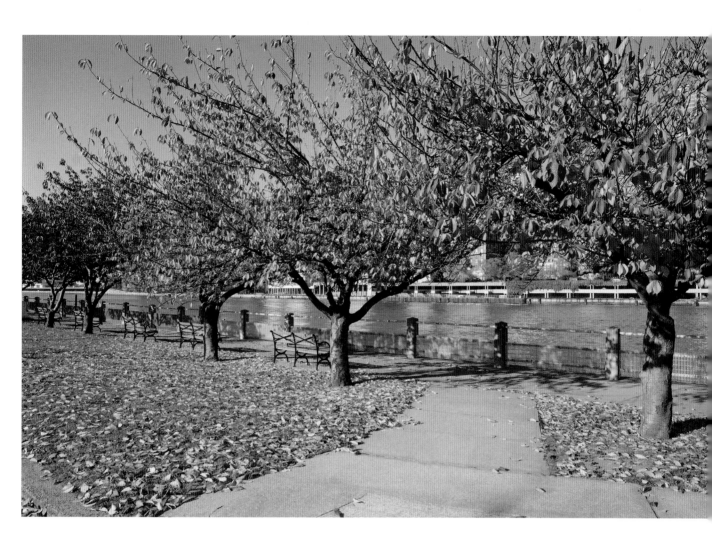

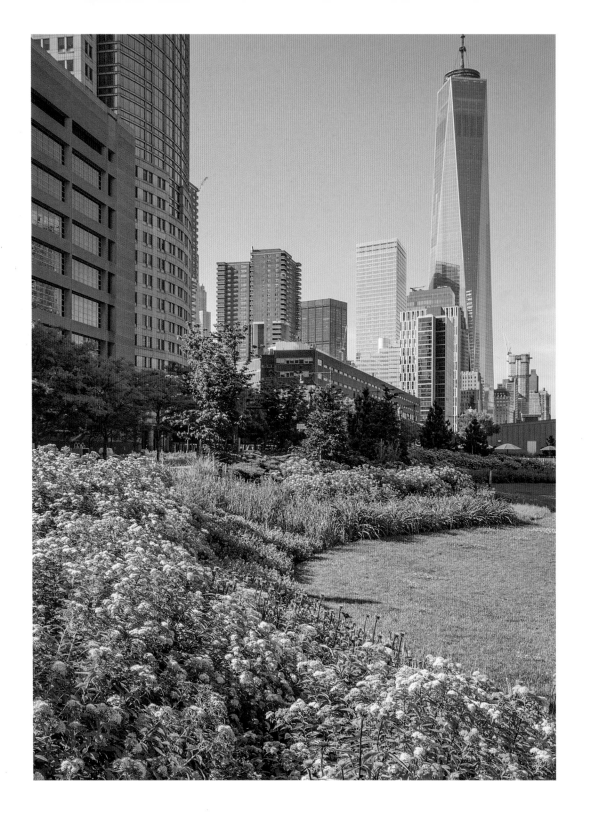

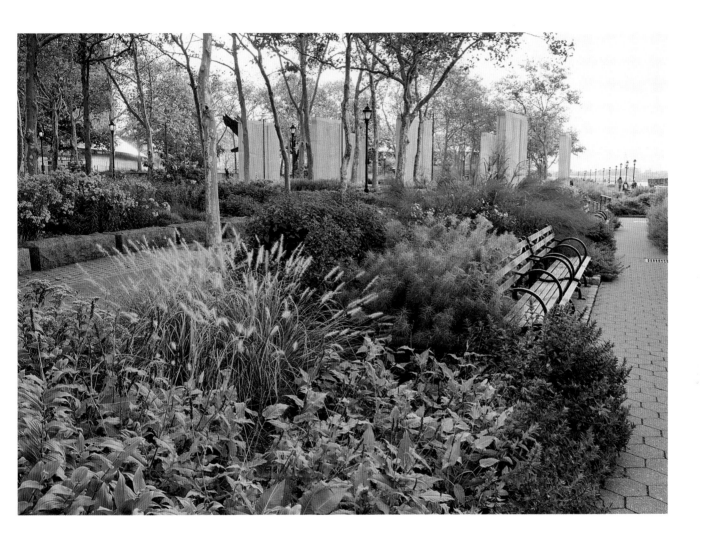

Opposite: A sweeping perennial border designed by Oehme Van Sweden slopes down to an expansive lawn in Rockefeller Park in Battery Park City.

Above: The Battery is a 25-acre public park at the tip of Manhattan, near the Staten Island Ferry Terminal. Garden designer Piet Oudolf designed the Garden of Remembrance with sweeping native grasses and flowering perennials. Benches are nestled close to the flowerbeds, creating the feeling of being enveloped by plants as you gaze at the river.

This section of the Battery is a grove of London plane trees with dramatic exfoliating bark. Densely massed below the trees are sweeps of perennials, including this large planting of knotweed 'Firetail.'

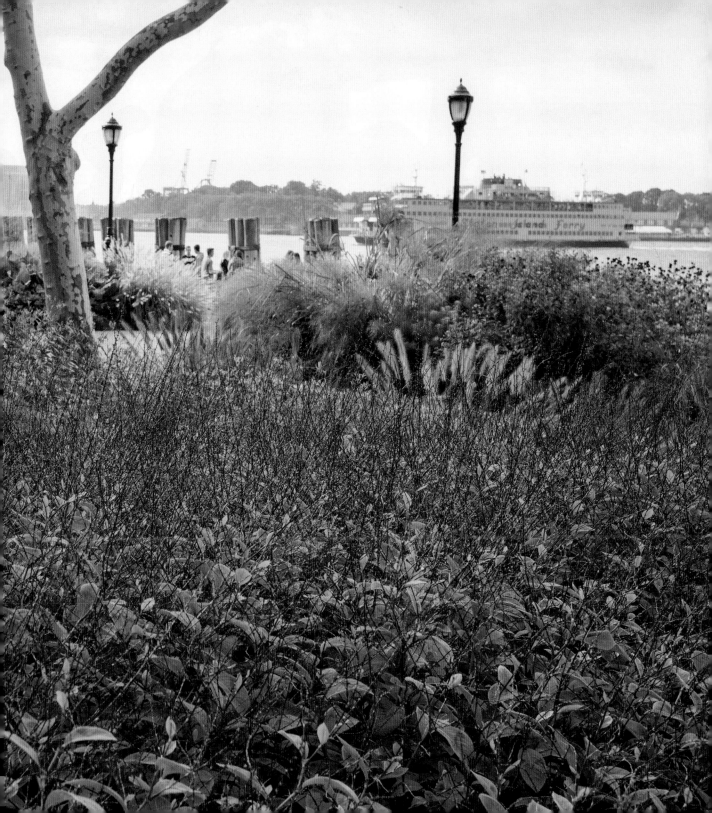

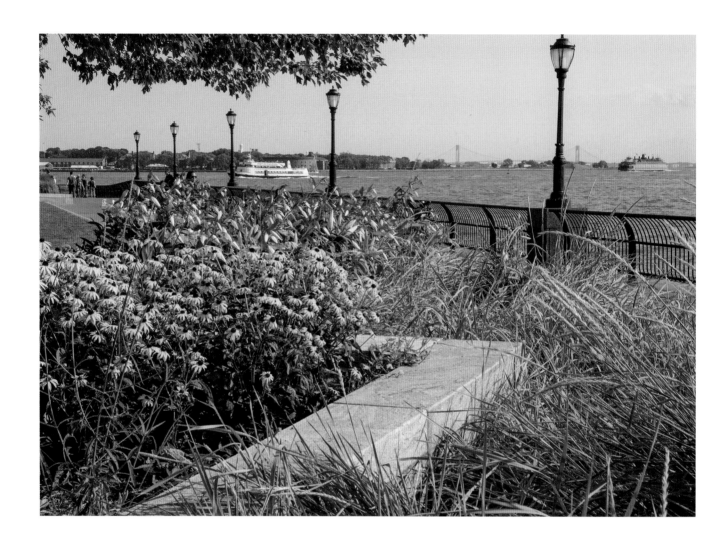

Above: In Rockefeller Park, a planting of grasses and black-eyed Susans, by Oehme van Sweden, does well in the full sun and wind coming off the Hudson River. In winter the seed heads provide food for birds.

Opposite: The lily pond, also an Oehme van Sweden design, is located near the Irish Hunger Memorial.

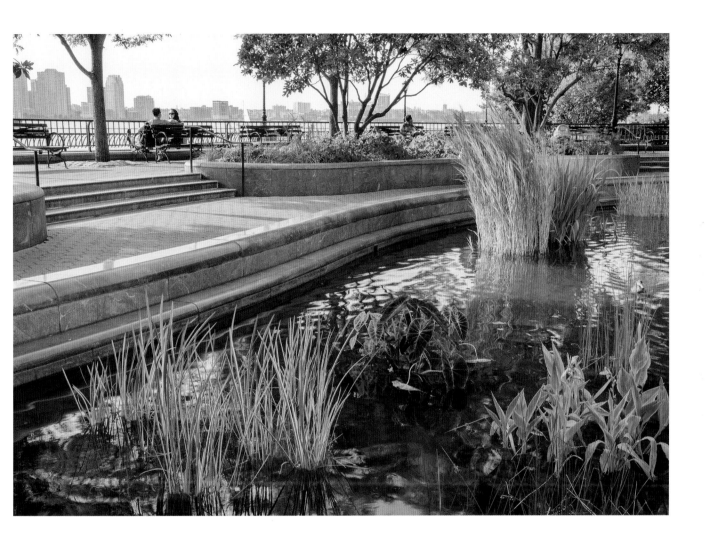

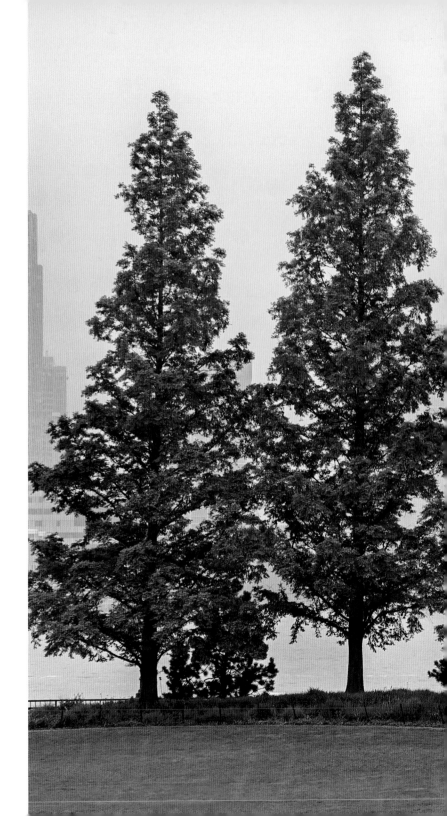

Four spectacular dawn redwood
trees are planted at the edge of
Rockefeller Park along the river.
These trees were thought to be
extinct, but a stand was discovered
in China in the 1940s. All dawn
redwoods in the United States are
descended from that group.

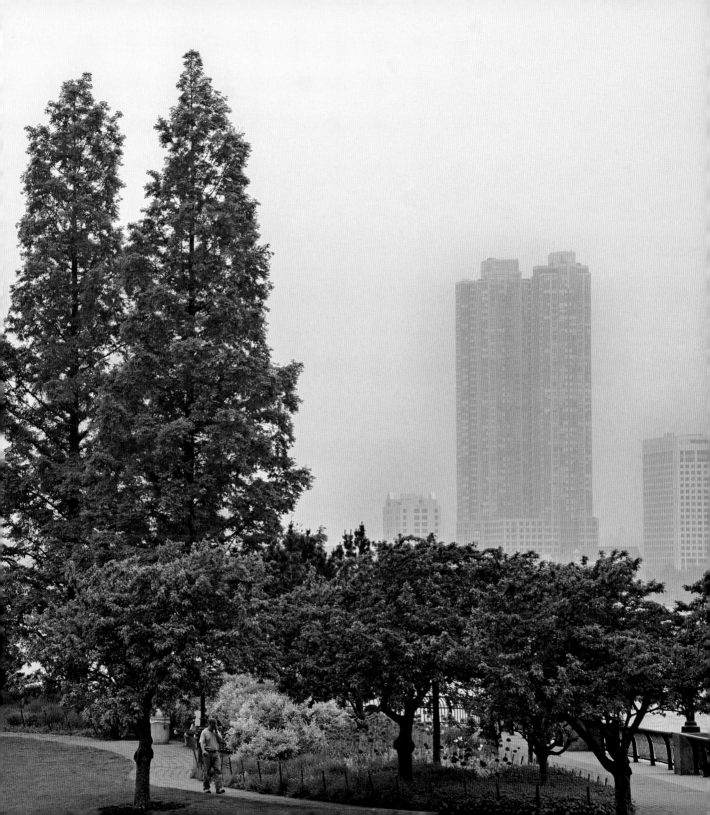

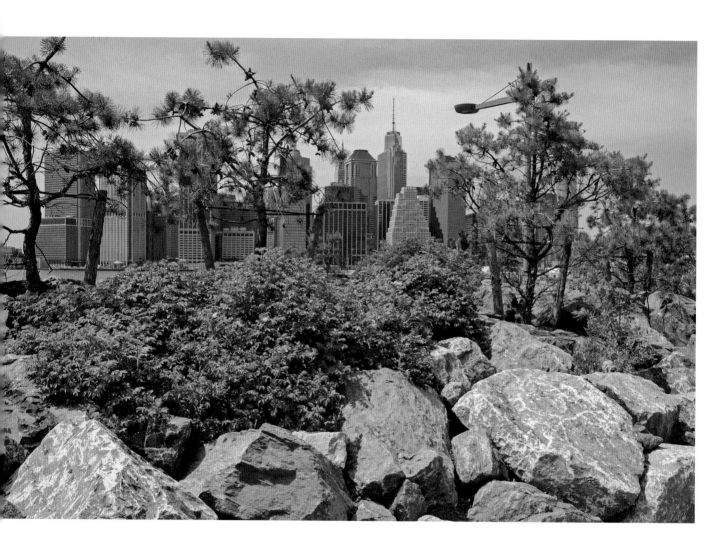

Above: Brooklyn Bridge Park is built on piers and landfill containing woodlands, wetlands, salt marshes, and meadows, as well as cultivated areas for recreation. This biodiverse park has a number of paths through various habitats and past spectacular views of Lower Manhattan. Tough native beach roses soften the granite boulders and waft their strong sweet scent on a hot day.

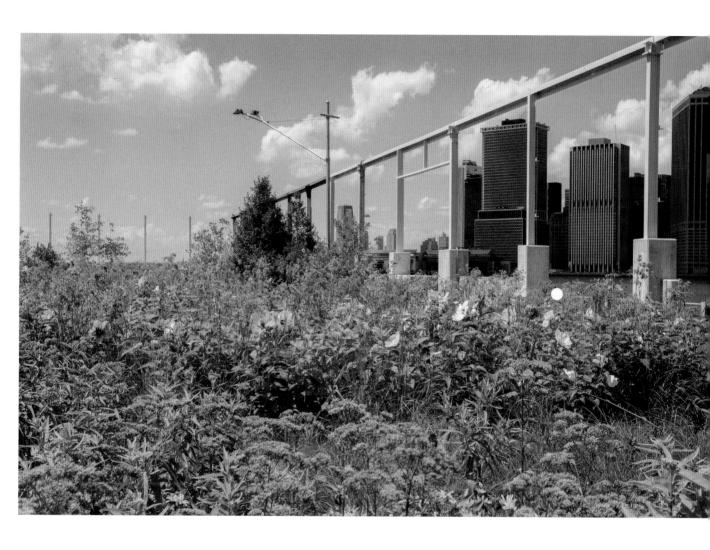

Above: This segment of the park features a meadow with plants that thrive in full sun and that are especially attractive to bees, butterflies, and birds.

Overleaf: A mass of Carefree Wonder rosebushes in shades of pink and white dominates the East River Park rose garden near the Williamsburg Bridge, which was replanted after Hurricane Sandy.

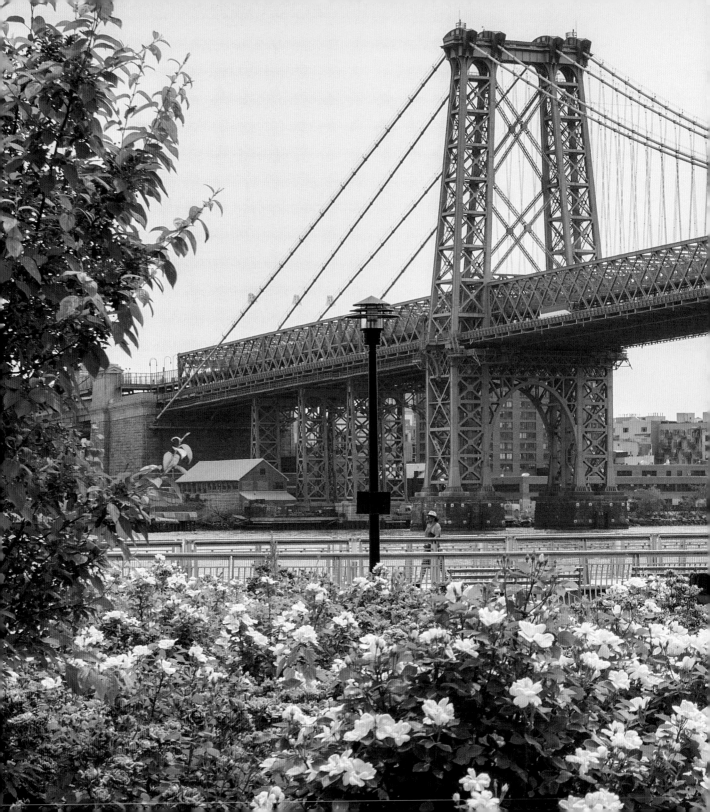

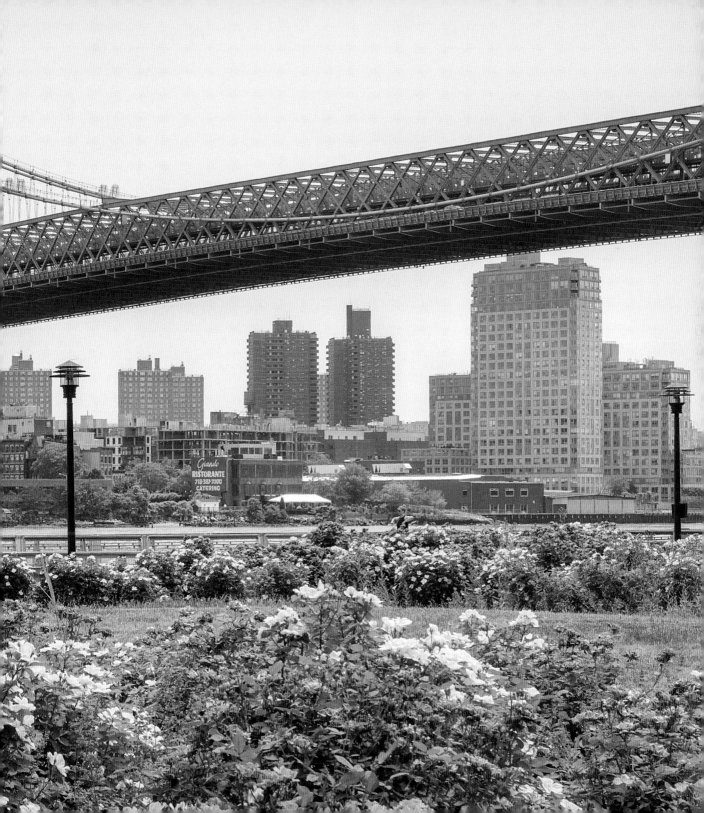

Index

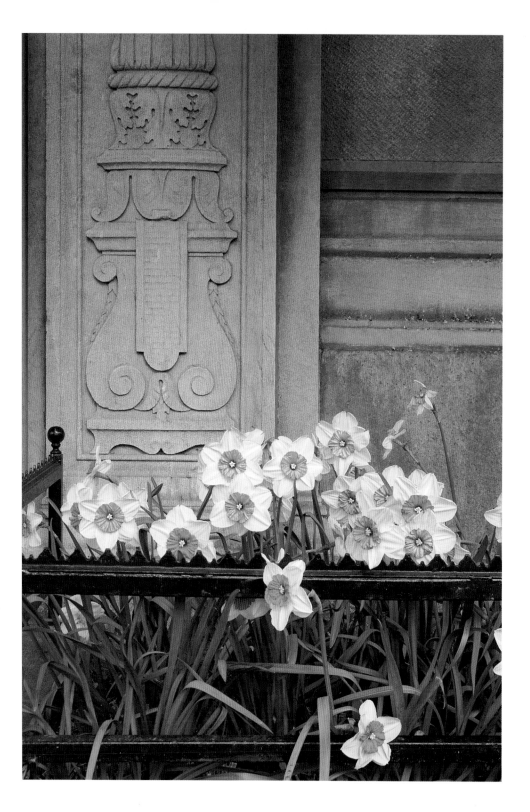

Acknowledgments

This book is a tribute to all the garden designers, landscape architects, volunteers, homeowners, park conservancy leaders, and city officials who applied their knowledge, talent, and support to make New York the increasingly beautiful green city that it has become. Particular credit is due to Mayor Michael Bloomberg and his administration for their commitment to parks and open space.

Special gratitude to those who took their time at the start of this project to introduce me to areas in each of the boroughs that were unfamiliar territory—Bob Berger (Bronx), Pauline Willis (Brooklyn), Lois Segman (Staten Island), Daniel Karatzas (Jackson Heights), and Edward Lee Cave (townhouse enclaves in Manhattan). My appreciation to Mary Jane Pool for her encouragement and insight in the initial phases of the project and to Elaine Peterson for introducing me to Alicia Whitaker, whose words complement my images so well. My husband, Edward Schiff, was an unswerving support throughout my many months of work. My gratitude to Jennifer Greenfeld of the New York City Parks Department for sharing her knowledge about the greening of the city. Finally, my deep appreciation to The Monacelli Press, particularly to Elizabeth White, who believed in the concept of the book and brought to it her editorial skill and experienced perspective.

Betsy Pinover Schiff

First published in the United States by The Monacelli Press.

Library of Congress Control Number 2016936157
ISBN 978-158093-464-0

Design by Susan Evans, Design per se, New York

The Monacelli Press
236 West 27th Street
New York, New York 10001

Printed in China